IMAGES
of America

SILVER SPRING
TOWNSHIP

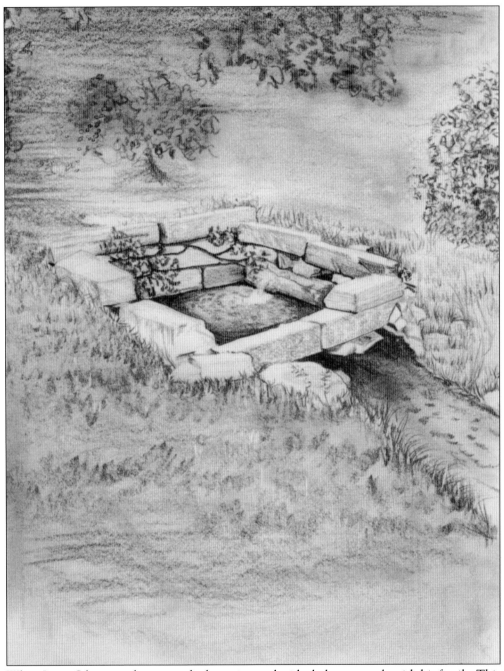

When James Silver saw this spring, he knew it was the ideal place to settle with his family. This sketch by Ted Baldwin shows the spring on the grounds of Silver Spring Presbyterian Church. (Courtesy of Silver Spring Presbyterian Church.)

ON THE COVER: Eight gentlemen strike a pose along the Cumberland Valley Railroad tracks, located between Locust Point Road and Appalachian Drive near New Kingstown. (Courtesy of New Kingstown Vision.)

Christine Clepper Musser
Foreword by Sen. Patricia H. Vance

Copyright © 2014 by Christine Clepper Musser
ISBN 978-1-4671-2189-7

Published by Arcadia Publishing
Charleston, South Carolina

Printed in the United States of America

Library of Congress Control Number: 2013953782

For all general information, please contact Arcadia Publishing:
Telephone 843-853-2070
Fax 843-853-0044
E-mail sales@arcadiapublishing.com
For customer service and orders:
Toll-Free 1-888-313-2665

Visit us on the Internet at www.arcadiapublishing.com

With love to my parents, Paul and Bernadine Clepper.

Contents

Foreword		6
Acknowledgments		7
Introduction		8
1.	Hogestown	11
2.	New Kingstown	23
3.	Churches	33
4.	Schools	47
5.	Farming	61
6.	Businesses	77
7.	Airport	87
8.	Post Office and Fire Companies	91
9.	Recreation	97
10.	Notable Mentions	117
Bibliography		127

Foreword

Christine Musser is a lifelong resident of the Cumberland Valley and holds a degree in American history. Her passion for preserving history was the driving force in writing this book. James Silver would have a difficult time finding any recognizable areas in today's Silver Spring Township other than the winding Conodoguinet Creek, the North Mountain, and Silver Spring Presbyterian Church. His world in 1730 consisted of twisting dirt paths, few settlers, and lurking Indians. The township was sparsely populated and dotted with stockades for mutual protection from the Indians. The natural beauty of the two towns, New Kingstown and Hogestown, has always been evident.

When our family first arrived in 1964, our home had a dirt path leading to the house and was surrounded by other farms. We arrived as a very young couple with two small children, full of dreams and plenty of naïveté. A push lawn mower and a snow shovel were our only means to tame the land. We soon learned there were almost no storm windows in our home and a huge oil burner that gobbled up the oil. Soon after we moved in, we ran out of oil on a very snowy night with two sick children. After many unsuccessful tries, the oil truck finally made it up the driveway. I was initially amazed to find the extremely low ceilings in the lovely barn but quickly discovered the floors were literally covered with feet of manure. The ceilings soon got higher with pitchforks and a lot of hard work.

The farm agent became my source of information, and over the years, we had a pig named Fifi, a horse, a pony, and black angus. It was a wonderful experience in outdoor living.

A bull lived in the pasture where the gas station now sits at the corner of Routes 11 and 114, which was a two-lane road. Route 81, the turnpike, and the railroad brought many changes, both positive and negative. Population grew, traffic increased, and there was quicker access to other localities, but there was also increased truck traffic and demand for emergency services. The Carlisle Pike has changed dramatically. Gone are the Silver Spring Drive-In Theater, the Rainbow Roller Rink, the root-beer stand at Hogestown, and Silver Spring Race Way and Flea Market.

The locations of the high school, middle school, and two elementary schools within the township have contributed to its rapid growth. Township residents were quite upset when people referred to the district as "Cow Valley." The dome on the gym serves as a landmark for pilots in the valley. A full-time police force was founded in 1969. Hurricane Agnes changed some of our history when the forces of nature caused the demise of the covered bridges and Willow Mill Amusement Park.

There is still a lot of room to grow, as the township has an area of 33.6 square miles. Silver Spring is the fastest growing township in Cumberland County and the fourth fastest in Pennsylvania. Recently, citizens of the township displayed their love of their surroundings by voting to tax themselves in order to preserve farmland.

The township has always been blessed with natural beauty and dotted with limestone buildings along the hillsides of the Conodoguinet Creek. The future will surely produce many more changes, but with careful planning, we can preserve its natural beauty for future generations.

—Sen. Patricia H. Vance

ACKNOWLEDGMENTS

I am so humbled by all of the support I have had in doing this book. I cannot begin to show the amount of gratitude I feel for those who have been willing to let me come into their home or their organization, most of whom I never knew before, and share their stories and photographs with me. They include Mary Deitch, Mel Raudabaugh, Rich Shoaff, Ted Adams, Alan Kreitzer, Nancy Konhaus Griffie, Betty Wade, Star Gaston Offenger, Bill Goetz, Nancy Hornberger, Jim Hall, Doug McDonald, Steve Taylor, Dolly Berkheimer, Patty Heishman Moore, Cindy Alleman, Greg Lucas of the Cumberland Valley School District, New Kingstown Vision, Carol Adams of Silver Spring Presbyterian Church, Jody Norrie of Trinity United Methodist Church, Richard Tritt of the Cumberland County Historical Society, Stephen Bachmann of the Dauphin County Historical Society, Marilyn Swartz, Kevin Swartz, Creeden Sunday, Dawn Darkes, John Rice of Pennsy Supply, Elaine Humer Sweger, John Miller, Max J. Hempt, Jean Motter, and the Silver Spring Township supervisors. I want to especially thank Holly Sykes who helped me to stay focused and worked with me on designing the book.

I want to also thank my editor, Abby Henry Walker, for all of her help and patience as I prepared this project.

And thank you to my family, Daniel, Matthew, Amy, Rhianna, Gabriel, Emily, Sarah, Don, and Zachary. Without your love and support, I could have never accomplished the goal of finishing this book.

INTRODUCTION

Silver Spring Township lies in the middle of the North and South Mountains of Cumberland County, Pennsylvania, and west of the Susquehanna River. In the early 18th century, the primary inhabitants were the Iroquois nation, Susquehannocks, Shawnees, and Lenape tribes who, with fur traders, lived along the Conodoguinet Creek. By 1830, the area was a thriving community and in the early 1900s the township was known as a "jump-off" place for fun and relaxation.

The area known as Barrens was fertile and naturally clear of dense forest. It stretched west to Stony Ridge and north of New Kingstown. Today, Cumberland Valley High School sits in its shadows. In the early days of settlement, it was not unusual for settlers who lived near Stony Ridge to see Native Americans and wild animals wander the Barrens. Beyond Stony Ridge, the land was heavily forested.

The area was rich in fresh drinking water from the many springs that emptied into the Conodoguinet Creek. The dense forest consisted of locust, poplar, pine, and pin oak, and supplied the settlers with timber to build their homes. Deer, muskrats, beaver, and opossums were found in the valley. The waterways were full of fish, and wild berries were plentiful. The Great Valley was an ideal location for settlers; it was as fruitful as it was beautiful.

James Silver, of Scots-Irish descent, and for whom Silver Spring Township is named, left the eastern part of Lancaster County in December 1724 and crossed the Susquehanna River, arriving in Pennsborough Township, Lancaster County, also known as the Great Valley. He brought with him brightly colored blankets and ribbons, muskets and replacement parts, copper cooking pots, hatchets, iron mattocks, and juice harps to trade with the Native Americans who lived along the Conodoguinet Creek. Silver stayed in the area and eventually staked out land for himself.

The land west of the Susquehanna River was promised to the Iroquois nation and the Susquehannocks by Pennsylvania's founder, William Penn, so legally James Silver could not make claims on the land. So he staked his claim in the area of the spring by blazing trees, also referred to as a "hatchet tract."

In 1727, a scrimmage broke out between the Susquehannocks and the Shawnees, killing three Susquehannocks. The Iroquois, being dominant over the Shawnees, forced them to leave. The Lenape, also known as the Delaware, eventually camped in the area. By this time, many Scots-Irish had settled in the area, and by 1735, there were settlements from the western bank of the Susquehanna River to Maryland.

After William Penn's death in 1718, his sons opened the lands west of the Susquehanna to settlement. To gain legal ownership of the land, the provincial government developed the Blunston License in 1735. The primary settlers at this time were Scots-Irish. Among the early settlers of Silver Spring Township besides James Silver were James McCormick, J.C. Sample, Samuel Senseman, John Hogue, James and Matthew Loudon, and William Walker.

The early roads were Native American footpaths, and pulling wagons or riding horseback was not easy. On November 4, 1735, the Lancaster County Court, which had jurisdiction over the western side of the Susquehanna, appointed a commission of six men to oversee the building of a road from Harris Ferry, located on the banks of the Susquehanna River, to the Potomac

River in Maryland, which would be the first main road connecting the east with the west. Those appointed were James Silver, Randle Chambers, Thomas Eastland, John Lawrence, James Peat, and Abraham Endless.

In February 1736, the committee submitted its plan to the court, which suggested the road run through the Barrens. The plan caused tension among the settlers due to the Barrens being prime land and ideal for crop farming. A suggestion was made to have occupants from the eastern side of the Susquehanna develop a plan that would not be detrimental to the settlers. The Lancaster court agreed and set forth a new plan. The road was completed in 1741 and was referred to as the "Great Valley Road." Present-day Carlisle Pike follows the route of the early road.

The Native Americans and the settlers lived peaceably together, but that would change as more and more Scots-Irish moved into the Great Valley. The natives were becoming agitated as their hunting grounds were being developed into farmland. Benjamin Franklin encouraged the settlers to take military action against the natives. This prompted many settlers to build hideouts and fortresses where they could escape in case of attack.

Pennsylvania's governor, Robert Morris, attempted to smooth the tensions by inviting the tribes to Aughwick, home of Native American interpreter George Croghan, in the fall of 1755, and giving them gifts for the loss of their hunting grounds, but his plan failed. Later that fall, a group of Lenape led by Chief Shinga attacked 27 settlers at Parnell Knob located at the foot of the Kittatinny Mountain.

The battles between the settlers and natives intensified as the French and Indian War advanced. During this time, John Walker and another man were killed at McCormick's Fort near the Conodoguinet Creek outside of Hogestown. The once peaceful western frontier became a place of great animosity between the Native Americans and the Scots-Irish.

For ten years, Pennsylvania's leaders attempted to bring peace between the Native Americans and the European settlers. Finally, in 1765, relations between them were once again peaceful. This was mainly due to the natives' westward migration. By 1775, the Native American population had greatly decreased.

The Scots-Irish practiced the Presbyterian faith and built the first church west of the Susquehanna River near the spring on the James Silver property. This church, originally built from logs, today stands as a stone structure and remains in use.

Several villages were founded during the early years of Silver Spring Township, but the only two that have remained as functioning villages are New Kingstown and Hogestown. These villages have stories of their own and in some cases have served as a stepping stone for residents who moved on to become quite prosperous.

John Hogue settled on a large tract of land near Hogue's Run that includes present day Hogestown in 1730. He participated in organizing the Silver Spring Presbyterian Church that was built on James Silver's property. He died on his estate in Hogestown in 1748 and was buried in the Silver Spring Presbyterian Church Cemetery.

Three miles west of Hogestown is the village of New Kingstown. Joseph Junkin Sr., an immigrant from Ireland, settled in New Kingstown on January 1, 1738. Junkin was a member of the Reformed Presbyterian Church, also known as the Covenanters. Soon after his arrival to the Great Valley he organized the "Junkin Tent," where worship services took place. Joseph Junkin Sr. died in 1777, leaving his property to his sons, Joseph Jr. and Benjamin, and John Carothers.

In 1818, John Carothers sold his portion of the Junkin property to John King, after whom New Kingstown is named. King laid out the village of New Kingstown with most of the structures being log homes. Prior to the layout of the village, three stone houses were built by the Junkins. These homes remain today.

During the 19th century, Silver Spring Township residents witnessed the Civil War first hand. In 1863, Confederate soldiers passed through the township on their way to Harrisburg. The soldiers camped at Stony Ridge, at the Hogestown Run, and on the grounds of the Silver Spring

Presbyterian Church. There were no major altercations within the township, but in nearby Carlisle, the Army War College was shelled. The homes of Mechanicsburg residents were raided by the Confederate soldiers.

For its first 170 years, Silver Spring Township witnessed much growth despite all the challenges the residents endured. By the turn of the 20th century, Hogestown and the area around the Conodoguinet Creek were considered a resort area where many affluent people came to vacation. The township continued to grow throughout the 20th century, and today is considered an ideal location to live and visit.

One

HOGESTOWN

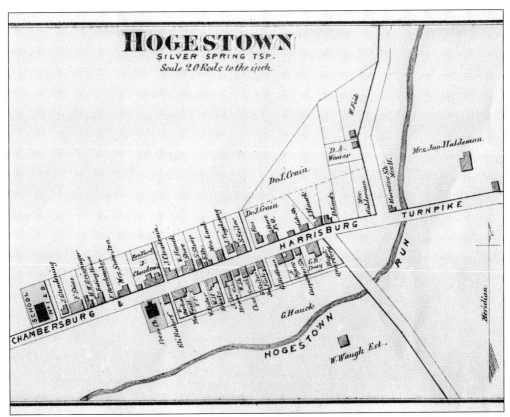

This map shows what Hogestown looked like in 1872. The three Hogue houses, which were built in the early to late 1700s, remain today. Their locations on this map are: W. Waugh, south of Hogestown Run; G.R. Duey (marked "Head-quarters"), at the intersection of Village Road; and the Mrs. Jno. Haldeman farm to the east. (Courtesy of Ted Adams.)

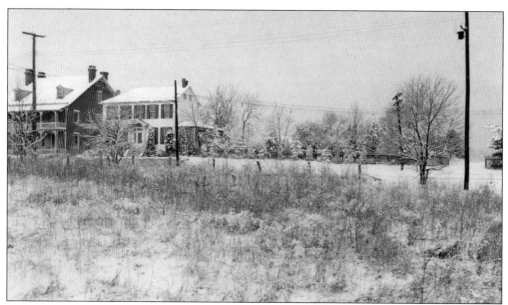

The A&W Drive-in, known for its famous root beer and homemade subs, was built on the empty lot on the east end of Hogestown. When customers drove up to the drive-in, a waitress would come to the car, take their order, and bring the order out on a tray that connected to the driver's-side door. Jugs of root beer could be purchased to take home. Today, Al's Pizza stands where the A&W once stood. (Courtesy of Elaine Humer Sweger.)

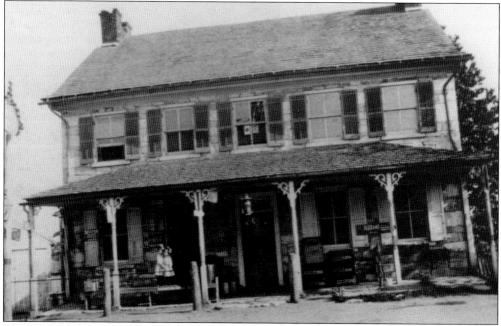

Walter Rohland purchased the former Hogue Tavern in Hogestown and turned it into a general store. Inside the store was a living area where Rohland and his family resided. An American Red Cross poster is in the middle window of the second floor. The poster identified the general store as an official location for Red Cross donations, which went towards the support of American troops during World War I. (Courtesy of William Goetz III.)

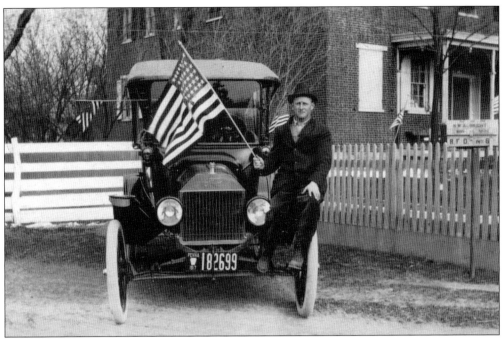

World War I, also known as the Great War, came to an end at 11:00 a.m. on November 11, 1918. Once the news was heard around the world, major celebrations took place. In Hogestown, a parade was planned that included the proud display of the US flag. Red, white, and blue bunting was draped from buildings and around people. Car horns honked, and the marching band played patriotic music. Pictured above at the Albright farm near Hogestown (the present-day location of the Cumberland Valley Vocational School), George Albert Waggoner proudly holds the flag while sitting on his Model T. (Above, courtesy of William Goetz III; below, courtesy of Elaine Humer Sweger.)

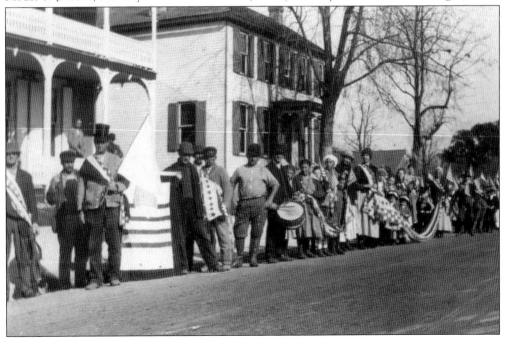

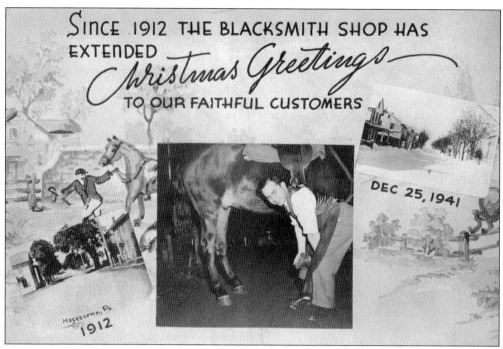

In celebration of the Hogestown Blacksmith Shop being in business for 29 years, Lawrence Humer designed this Christmas greeting card, on which he is pictured raising a horse's hoof. The only recorded blacksmith in Hogestown was Leroy Sutton, who also had a blacksmith shop in Lemoyne. (Courtesy of Elaine Humer Sweger.)

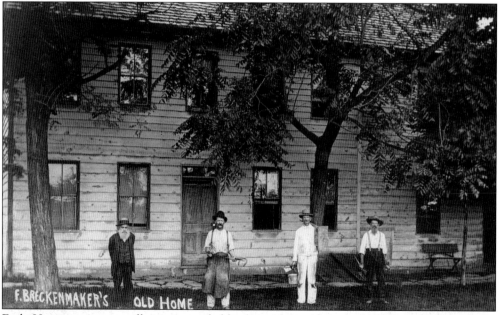

Early Hogestown was a village surrounded by farms. Its residents provided various services for the neighboring farmers. There were a number of summer homes, and residents who catered to vacationers. Pictured here from left to right are Frederick Breckenmaker, Leroy Sutton, a painter, and Charlie Smith. (Courtesy of Cumberland County Historical Society.)

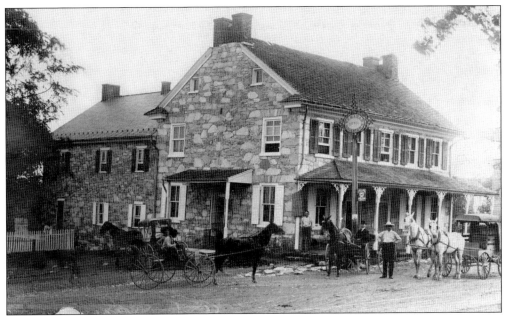

Built in 1794, the beautiful, large limestone Hogue Tavern has seen many owners. Located on the east end of Hogestown, it was the first building that travelers from Harrisburg would see. In 1805, Jonathan Hogue assaulted John Moser Sr. over a bar tab and was later indicted on assault and battery charges. The tavern was later known as the Sign of the Bear and Sign of the Buck. In 1909 Walter Mahan owned the building, which was then called the W.F. Mahan Hogestown Hotel. Here, he sold Dowhney Lager Beer, made in Lemoyne. Frank Buffington took ownership from Mahan in February 1910. The road that ran in front of the Hogue Tavern was the main road from Harrisburg to Carlisle. Because it was a dirt road, it became muddy during rainy days and made traveling a challenge. After long periods without rain, the road would stir up dust. (Above, courtesy of William Goetz III; below, courtesy of Elaine Humer Sweger.)

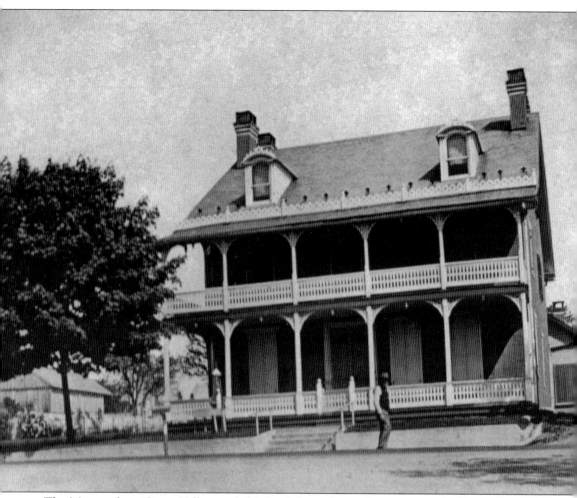

The Mussers from Camp Hill owned this brick home located across from the Hogue Tavern. They were one of many area families that built summer homes in the Hogestown area. The Boas family of the Harrisburg jewelry store was among the notable residents. The famous Deeter family, friends of the McCormicks, also summered in the area. Jane Deeter Rippen was a national director of the Girl Scouts. Her brother, Jasper Deeter, was a well-known actor, director, and producer on the Broadway scene and owned the Hedgerow Theatre in Rose Valley, Pennsylvania, near Philadelphia. Vacationers from Harrisburg, Philadelphia, and New York rode the train to New Kingstown, where they were retrieved by their hosts in a horse and buggy to take them to their destinations. (Courtesy of William Goetz III.)

One of the first gas stations with a grocery store in the area was opened in Hogestown, making it convenient for motorists who passed through the area to get gas and groceries. The business was owned by George and Belle Blessley, and according to a May 1915 *Harrisburg Telegraph* article, the Blessleys sold Atlantic gasoline. The store was also convenient for local residents. (Courtesy of Elaine Humer Sweger.)

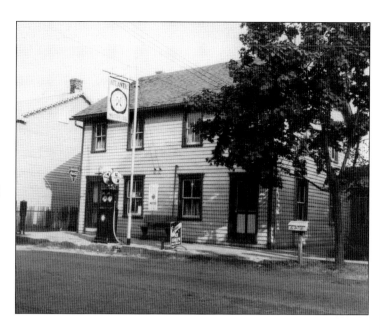

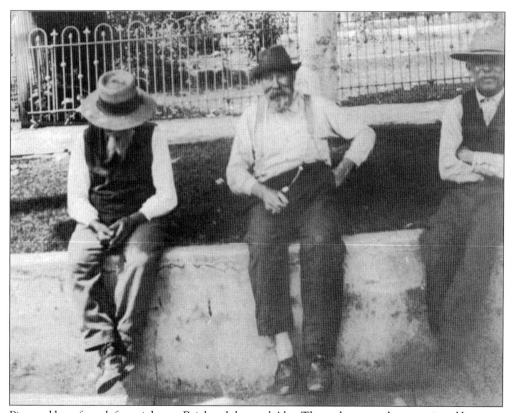

Pictured here from left to right are Bricker, Jake, and Abe. These three gentlemen enjoyed hanging out at Walter A. Roland general store and harness shop, located behind the store. They would linger at the store for hours and at times had to be asked to leave. (Courtesy of William Goetz III.)

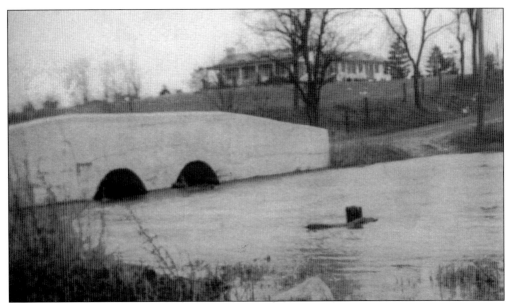

The bridge on the south side of Hogestown on Village Road next to Al's Pizza was originally built during the 19th century and was rebuilt by the Works Progress Administration in 1936. During this period, Route 11's northbound lane ran through the north side of Hogestown. To the far right of the bridge was one of four springs that contributed to Hogestown Run. Hogestown Run was once stocked regularly with trout, making it an ideal place for fishing. The spring supplied water to the Hogue house in the early 1900s. (Courtesy of William Goetz III.)

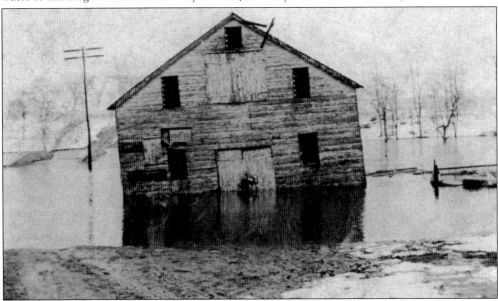

This photograph of the barn behind the Hogue house next to the Hogestown Run was taken prior to the addition of the northbound lane of Route 11. This flooding, which was referred to as the St. Patrick's Day Flood, was a result of snowmelt and rain that began on March 16, 1936, and lasted through St. Patrick's Day. The rainstorm that caused the flooding covered the entire Northeast and is considered the second-worst flood in Pennsylvania history. As a result of this historic flood, the Flood Control Act of 1936 was enacted. (Courtesy of William Goetz III.)

In the 1800s and early 1900s a weigh station was located behind the Hogue house. The building had doors on each end so the horse and wagon could come through one door, get weighed, and go out the second door, where the driver would pay his toll. The weigh station building is still standing. Another building on the Hogue property behind the weigh station was the blacksmith shop. These buildings were perfect for attaching advertisements and event flyers. (Courtesy of William Goetz III.)

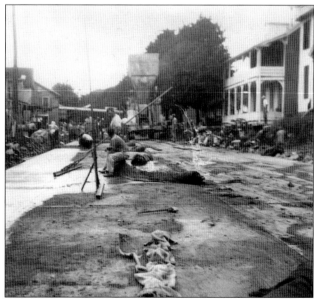

Since the settling of Cumberland County, its road infrastructure has always been an issue. During the Depression, Pres. Franklin Roosevelt approved the Works Progress Administration. This action had the dual purpose of putting people to work and improving roads. In September 1936, the road through Hogestown was being reconstructed. While working on the road, the construction workers drank from the Hogestown Run and fell ill with typhoid. Typhoid became an epidemic and many lives were lost, including those working on the road. (Courtesy of Elaine Humer Sweger.)

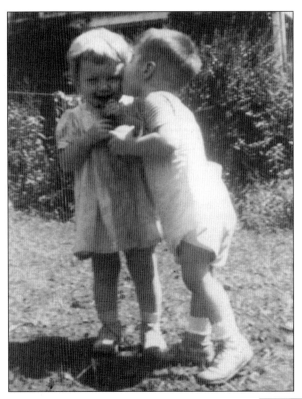

Ice cream on a warm summer day is always a refreshing treat. William Goetz III's mother did not pass up the opportunity to snap a photo of her young son kissing her niece, Gloria Rice, on the cheek while she ate an ice cream cone. (Courtesy of William Goetz III.)

William B. Goetz and William Goetz III are pictured in 1944. Goetz was home on leave to visit with his family. Little William is standing on a Lightning Glider sled constructed at the Old Sled Works in Duncannon, Pennsylvania. In the background, the Musser house can be seen on the left and the Humer house on the right. (Courtesy of William Goetz III.)

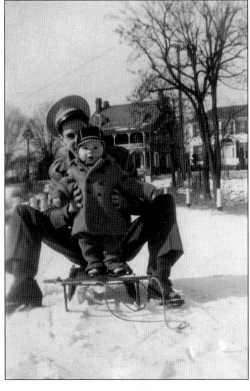

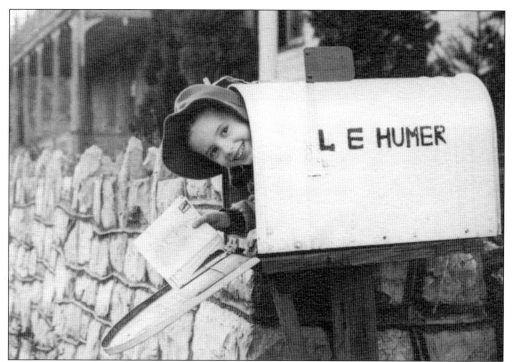

Lawrence Humer enjoyed taking fun photographs, especially of his young daughter Elaine. In the 1940s, he photographed Elaine, smiling from ear to ear and holding a Christmas card, popping out of the mailbox at his Hogestown home. (Courtesy of Elaine Humer Sweger.)

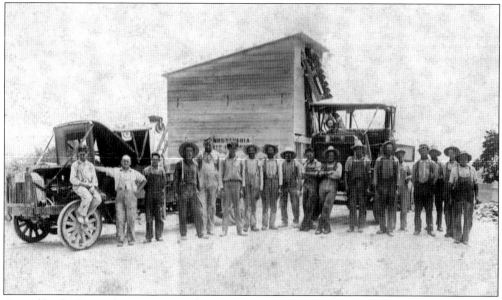

Owned by the Pennsylvania State Highway Department, the limestone quarry was located up from the springhouse and was used to crush limestone found on that property. In the early 20th century, limestone from the quarry was loaded onto trucks and distributed throughout the area to make roads. In September 1920, the quarry blasted 2,000 pounds of Atlas powder, the biggest blast of that time. The blast turned out approximately 20,000 tons of stone. (Courtesy of John Miller.)

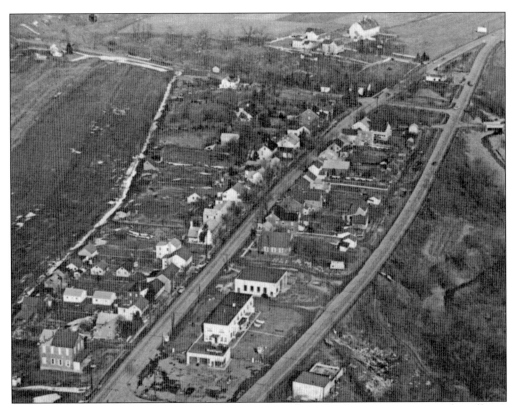

What started as timberland is now a small community of people who want to preserve the village's history. There are a few residents who still remember when Hogestown only had a two-lane road, and they recall having to give up their front yards when the highway came through. They remember going to the village grocery store with their parents. Today, they witness the heavy traffic that travels through their village. Many of the homes still remain from the early years, although some that were built from logs taken from the area are now encased with aluminum siding. (Above, courtesy of Cumberland County Historical Society; below, courtesy of Alice Seaman.)

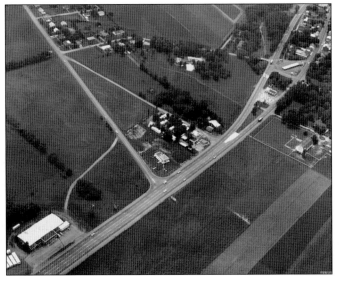

Two

NEW KINGSTOWN

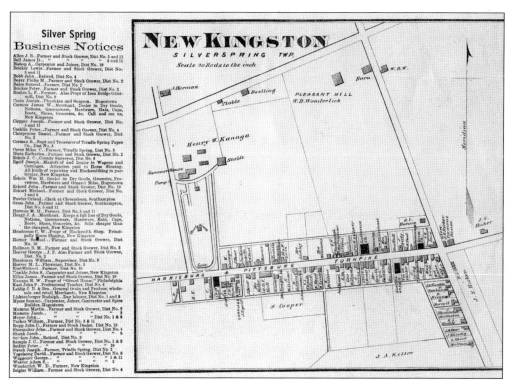

The Village of New Kingstown is located west of the Village of Hogestown. In 1872, the village had approximately 370 residents, 84 dwellings, two stores, two confectionary shops, two carriage shops, one blacksmith shop, three churches, one school building, and one hotel. Farms surrounded New Kingstown, and the Chambersburg and Harrisburg Turnpike ran through the center of the village. A half mile to the south was a large grain warehouse alongside the Cumberland Valley Railroad tracks. New Kingstown was a regular stop for the railroad, becoming a popular destination when the Kanaga House was a resort. (Courtesy of Ted Adams.)

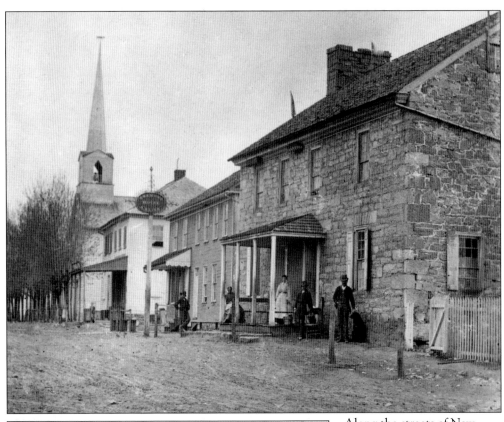

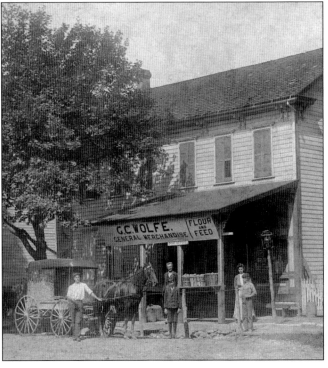

Along the streets of New Kingstown lived people of various economic levels along with businesses to serve them. Residents and visitors had to tolerate muddy roads and mud pasted to shoes, boots, and the bottom of dresses. At left, in front of G.C. Wolf's General Mercantile at Main Street and Creamy Road (present day Locust Point Road), are sacks of feed and bushels of potatoes for sale. Inside the store, shoppers picked up the latest clothes or material to make a dress. The local post office was inside. Children shopped for penny candy, jacks, and other items to entertain them. The store is no longer there. (Both, courtesy of Ted Adams.)

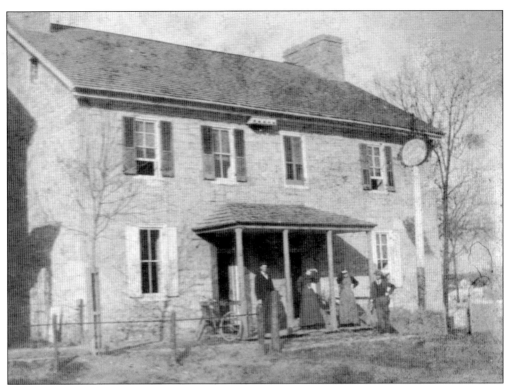

In 1790, Benjamin Junkin built this building to serve as an inn and a tavern, and it became known as the Sign of the Lyon. In the center hall, there was a kitchen and a large cooking fireplace. The second floor had five rooms that included a moveable partition wall, which could turn the upstairs into a ballroom. On the front of the building was a purple martin birdhouse that helped to keep insects away. The building was later sold but remained a tavern and inn for 100 years. In this photograph, it was the Tremont House. Today, it is a private residence. In 1912, a store was located beside the tavern. Below, hanging on one of the poles that held up the porch roof was a sign that advertised phones located within the store. (Both, courtesy of Ted Adams.)

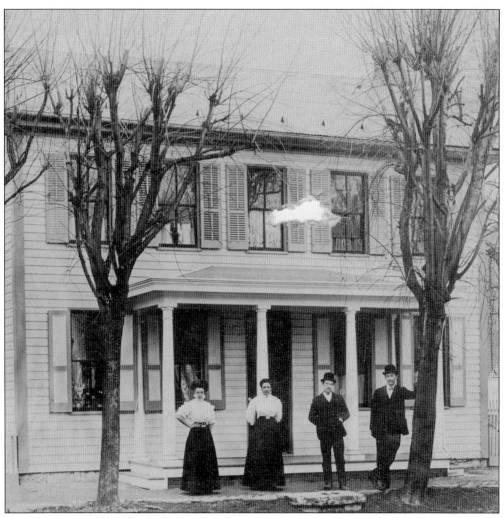

Liz and Harry Griffith lived two doors west of the St. Stephen Evangelical Lutheran Church. Mr. Griffith worked as a stone mason. His daughter, Sarah, married Wilbur Sadler, who worked for the Cumberland Valley Railroad. While living there, they regularly entertained out-of-town family and friends. Visiting family, friends, and doing business was often reported in the local newspapers. Pictured here from left to right are Sarah Griffith Sadler, Elizabeth Griffith, Harry Griffith, and Wilbur R. Sadler. (Courtesy of Ted Adams.)

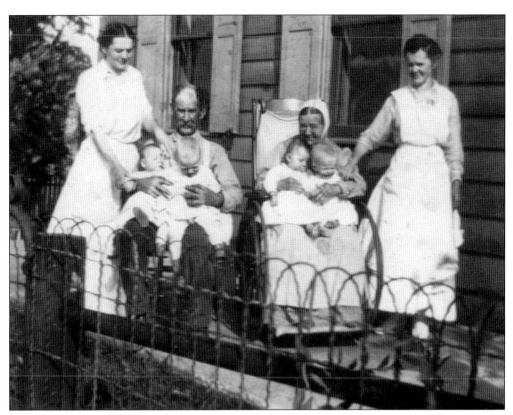

Joshua and Annie Hess moved to New Kingstown in the late 1870s from Perry County. Hess was a tenant farmer at the Musser farm in New Kingstown until he retired in 1918. He then moved to Mechanicsburg. His granddaughter Floetta Beistline Clepper grew up in New Kingstown. In an early edition of the *Mechanicsburg News*, Floetta reminisced about the "old pump" in front of the Tremont House and the water trough. She stated that most of the residents from New Kingstown obtained water from the pump. The schoolchildren from the New Kingstown School took turns carrying a bucket of water on a pole to the school. (Both, courtesy of Christine Clepper Musser.)

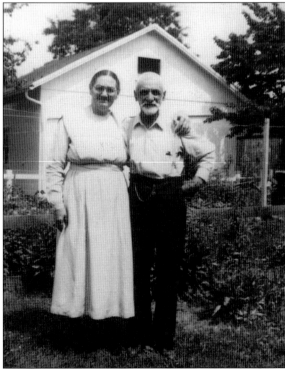

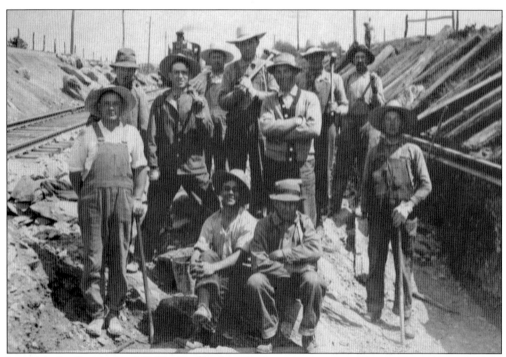

In 1904, the Cumberland Valley Railroad made improvements by adding a second set of tracks between Middlesex and New Kingstown. This endeavor straightened the tracks, thereby enabling the fast train to cut minutes off its travel time. Milk-truck drivers would drop off cans at the train station, which were then taken to the milk plant and bottled. The train station opened at 8:00 a.m., frequently an inconvenience for passengers who caught the earlier train. In 1921, New Kingstown residents petitioned the Public Service Commission to employ an attendant to open the station at 5:15 a.m.—20 minutes before the train arrived—and at 6:55 a.m. for the 7:15 train. The railroad authorities and the Public Service Commission approved the request. (Above, courtesy of Ted Adams; below, courtesy of Cumberland County Historical Society.)

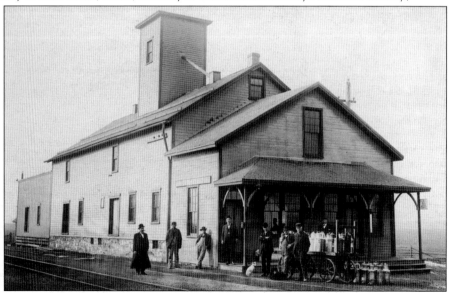

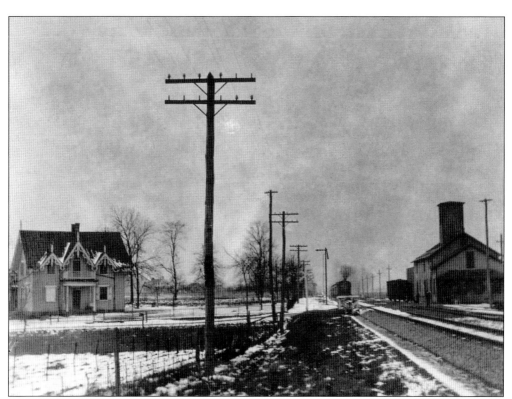

Fast trains were important to the area and to the nation. It was a 24-hour service that got mail, produce, and grain to places faster. Hobos regularly hung out around the New Kingstown train station. They would jump a train and ride for free. Sometimes, they would lay flat on the roof of the train or jump into a car that had its door open. The telegraph lines along railroad tracks were necessary for communication between the dispatch office and the individual signal locations—keeping track of the location of the trains was important. The lines also provided electrical power to run the signals and wayside detectors. (Both, courtesy of Ted Adams.)

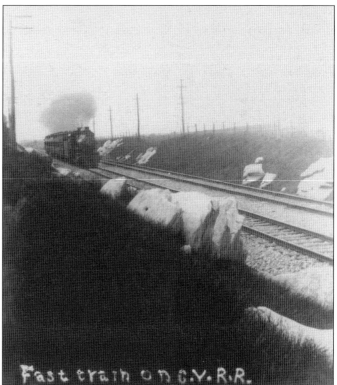

Residents of the Cumberland Valley complained often to the Cumberland County commissioners about the state of the roads. The county was responsible for the upkeep of the Chambersburg and Harrisburg Turnpike. In 1937, the roads between Harrisburg and Carlisle improved as part of Pres. Franklin Roosevelt's New Deal. Traveling east from New Kingstown in the 1940s, travelers would pass Hempt Farm and the future home of Cumberland Valley High School and Administration Office. Traveling west toward New Kingstown, travelers would go through the village of New Kingstown toward the county seat of Carlisle. Here, travelers could pick up the Carlisle/Pittsburgh Turnpike. Today, the turnpike goes from Pittsburgh to Philadelphia. (Both, courtesy of Patty Heishman Moore.)

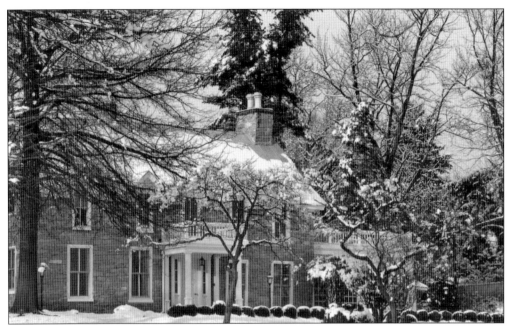

The stately Kanaga House was built in 1775 by Joseph Junkin. The first Covenanter communion in the United States took place on Kanaga grounds on August 21, 1752. In later years, the "Widow Junkin's Tent," also called the "Buchannan Tent," took place here. "Tent" refers to the place where revival meetings were held. During the Confederate invasion of the Cumberland Valley in June and July 1863, rebel soldiers camped here. (Courtesy of New Kingstown Vision.)

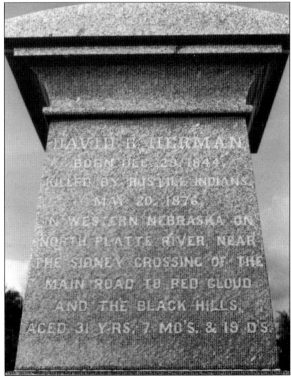

This headstone is located in Longsdorf Cemetery, just south of New Kingstown. David B. Herman, the brother of the prominent Judge Sadler, traveled west to work with the Boslers on their cattle ranch in Nebraska in the early 1870s. This was a period of unrest in the western plains. Native Americans were forced to move to reservations, causing much hostility. On May 20, 1876, one month before the Battle of Little Big Horn, Herman was crossing the North Platte River with the Boslers' cattle when he was attacked and killed by a group of Native Americans. His body was transported back to Pennsylvania, with George Bosler accompanying the casket. (Author's collection.)

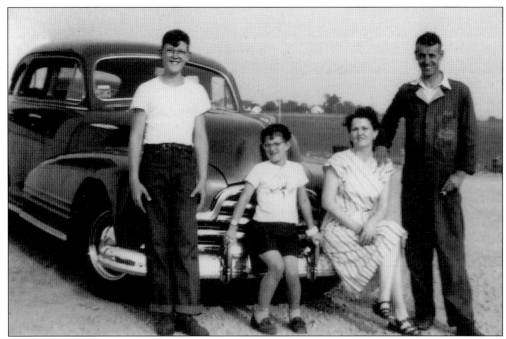

Pictured here from left to right are Sonny, Patty, Mary, and Lafayette Heishman. This photo was taken at the Heishman Truck Stop and Restaurant, which was located on the east end of New Kingstown. Lafayette was the owner of the truck stop. (Courtesy of Patty Heishman Moore.)

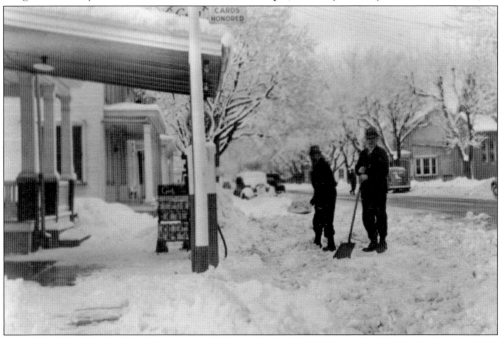

Part of living in the Northeast is the need to shovel snow. This is especially important for businesses in order for their customers to park. Dressed in layers, Melvin Raudabaugh and a helper shovel snow from the gas pumps at the front of Aunt Nellie's store, located next to the New Kingstown School. (Courtesy of New Kingstown Vision.)

Three

CHURCHES

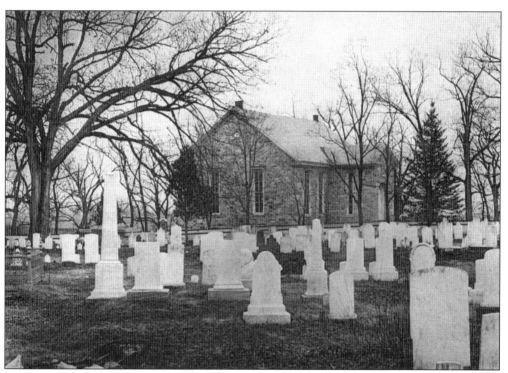

The Silver Spring Presbyterian Church and its cemetery are historically significant to Silver Spring Township. The church is located on the original location of the log church that was built by the Scots-Irish in 1775. The builders of this church, known as the "Meiting House," were referred to as "the people over the Susquehanna." As seen here, the church was completely made over in the Victorian style in 1886. The interior balcony was removed, and a vestibule and a chancel area were added. Today there are 13 active churches throughout Silver Spring Township. (Courtesy of Silver Spring Presbyterian Church.)

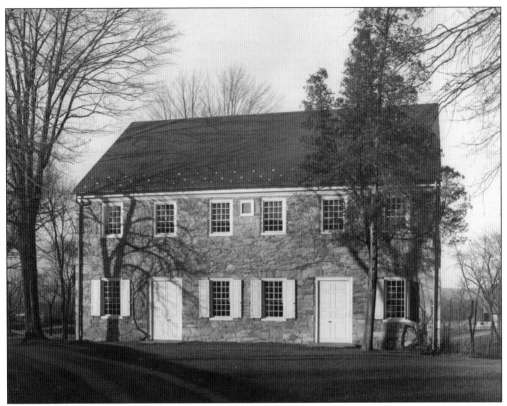

In 1929, Silver Spring Presbyterian Church underwent a major change to restore it back to its original look, which is how it stands today. The funding for the renovation came from the generosity of Vance, Henry, and Anne McCormick. The McCormick family dates back to the church's early beginnings. (Courtesy of Silver Spring Presbyterian Church.)

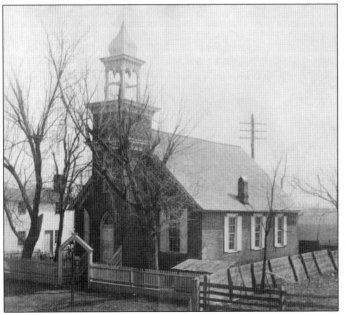

Hogestown Presbyterian Church, located in the village of Hogestown, is a sister church of Silver Spring Presbyterian Church. Traveling the two miles from Hogestown to Silver Spring Presbyterian Church during bad weather was a challenge. In order to accommodate the parishioners, Hogestown Presbyterian Church was built in 1858. Sunday school was the only service offered at the church. It also was used as a place for community meetings and later was reconstructed into a residence. (Courtesy of Jean Motter.)

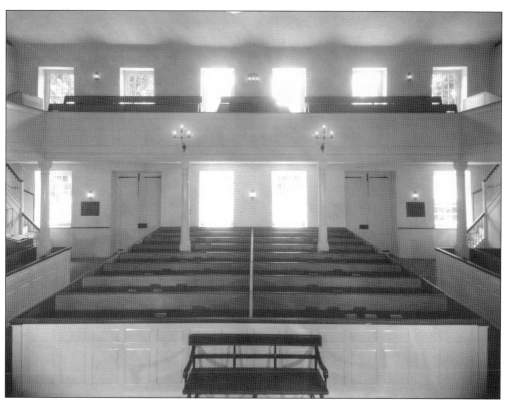

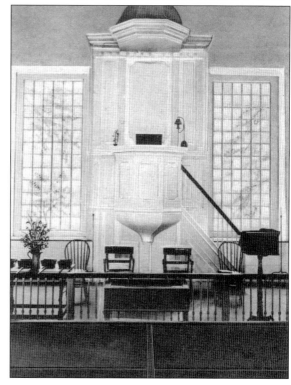

The pews in the Silver Spring Presbyterian Church were reconstructed to their original look of the 1700s. All the construction was done by hand using period tools. The balcony overhead was also reconstructed. During the reconstruction, the original log structure from the early 1700s was revealed. The wine glass pulpit was done by hand, along with the chancel railing. This was part of the original church building. After the renovations were completed, Anne McCormick, who remembered what the church looked like prior to the 1886 changes, expressed her amazement and stated the church looked exactly the way she remembered it as a little girl. The pewter used during the first Communion was donated by the Hogue family. This pewter continued to be used for some years after the first communion, but is now preserved. (Both, courtesy of Silver Spring Presbyterian Church.)

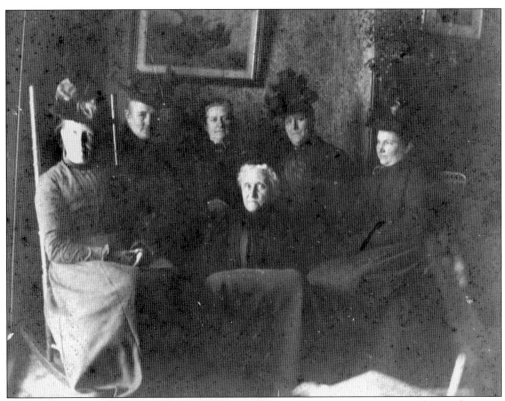

The Silver Spring Township Ladies Missionary Committee, pictured above, held monthly meetings. They had a yearly event in the church grove for the Home and Foreign Missionary Society of the Pine Street Church of Harrisburg. The ladies also planned fundraisers for missionaries. Besides being part of a church committee, church members may serve as ushers. The duties of ushers include welcoming worshippers, distributing church bulletins, seating worshippers, and collecting offerings. The lead usher is part of the Worship Committee. There are a total of four ushers. (Both, courtesy of Silver Spring Presbyterian Church.)

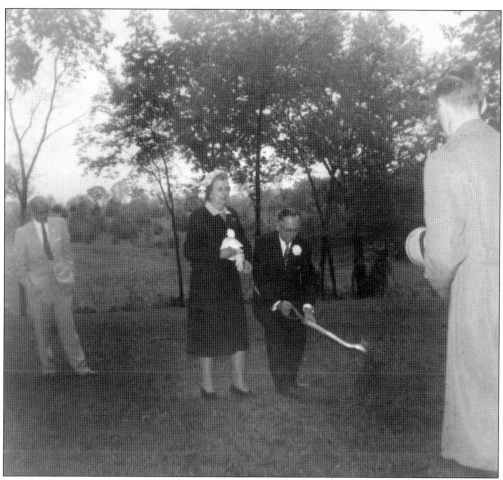

In May 1960, The Silver Spring Presbyterian Church broke ground for its new educational center and administration offices. The center offers preschool education to children within the community and also rents the gym for outside community events. Charlie and Mabel Meily posed during the ground breaking event. At left, on May 25, 1960, Walter E. Basehore, chairman of the Building Committee (far right), organized the laying of the cornerstone for the education center. (Both, courtesy of Silver Spring Presbyterian Church.)

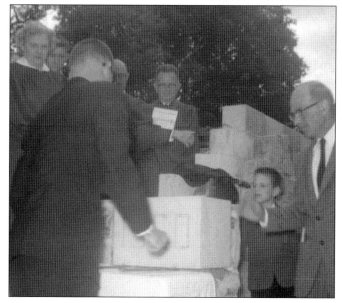

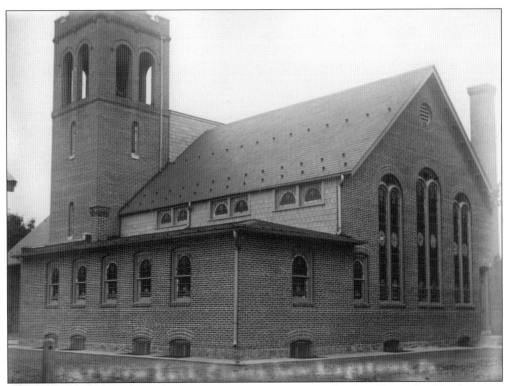

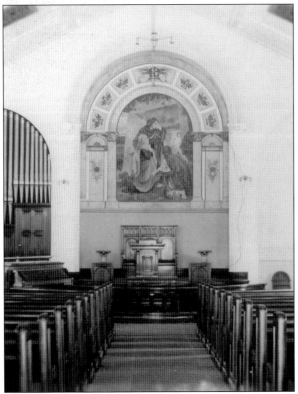

St. Stephen Evangelical Lutheran Church was first built in 1774 on land once owned by Henry Longsdorf. The church was first called Longsdorf Church and was located beside Longsdorf Cemetery. In 1839, Rev. Nicolas Stroh believed the church needed to be within the boundaries of the Village of New Kingstown, so against some of the parishioners' wishes, the church was moved. The new church had its name changed to Constitution of the Evangelical Lutheran Congregation of St. Stephen's in Kingston. It eventually changed its name to St. Stephen Evangelical Lutheran Church. In July 1911, the church was destroyed by fire along with much of the north end of the village. Plans to rebuild began immediately and the cornerstone was laid in May 1912. As part of the rebuilding process, a fresco of *Three Marys at the Tomb* was added to the church sanctuary. (Both, courtesy of New Kingstown Vision.)

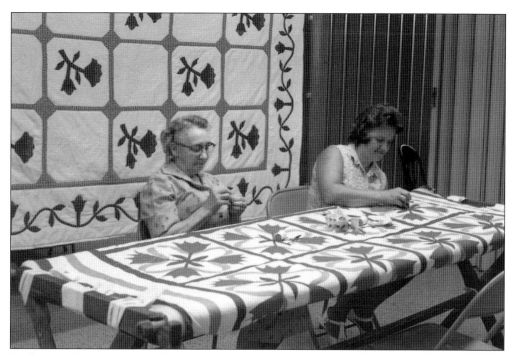

Quilts are a Pennsylvania tradition and a good source of money when fund-raising. Ladies at St. Stephen Evangelical Lutheran Church make quilts to auction off during their annual community Apple Festival, which started in 1970. In colonial tradition, apple butter is made over an open fire and sold at the festival. In addition to the apple butter, homemade vegetable soup and apple cider can be purchased. During the Apple Festival at St. Stephen, Tim Stouffer demonstrated how logs were cut during the Colonial period. Stouffer used a peavey, a traditional logging tool, to jack up the log to make cutting and moving it easier. The festival is held on the church grounds, and all proceeds go toward needy families in the area. (Both, courtesy of Cumberland County Historical Society.)

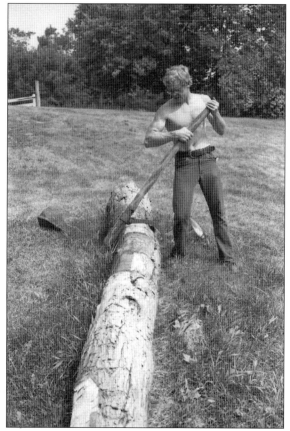

From left to right at the St. Stephen Evangelical Lutheran Church Apple Festival are Arthur Grove Sr., Glen Yohn, Lloyd Clemens, Ed Lovell, and Mabel Sollenberger. (Photograph by Sharon L. McDonald; courtesy of Cumberland County Historical Society.)

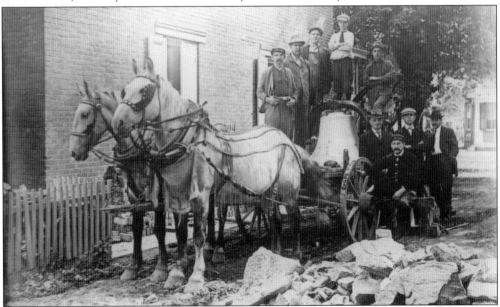

In 1911, when St. Stephen Evangelical Lutheran Church burned, a few items were salvageable, including the church bell. George Reed, Charles Sadler, Raymond Shank, Harold Meredith, Clarence Sadler, Charles Hetrick, Fred Bream, Ed Herman, and William Raby delivered the bell to St. Stephen in May 1912. The community of New Kingstown came together to raise funds to help pay for the rebuilding of the church. A bazaar was held at the Odd Fellows Hall under the guidance of George Miller's Sunday school class. The bazaar included a candy and cake booth, poultry supply booth, pure food booth, lemonade booth, fancy work booth, ice cream booth, and a fish pond booth. (Courtesy of New Kingstown Vision.)

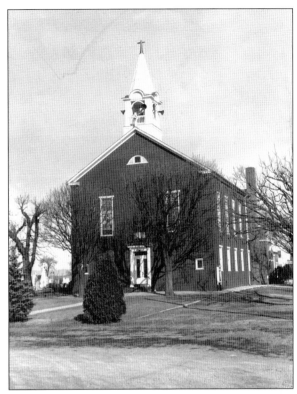

In 1765, William Trindle deeded the land to the German Lutheran and German Reformed Calvinist parishioners to build a church and lay out a cemetery. He was a Scots-Irish tailor, Indian trader, and community leader. The first church was a log building, later replaced by a brick structure in 1823. Eventually the German congregations left the church in 1875. The church later became the Trindle Spring Lutheran Church. It has a unique interior in that it has a second floor sanctuary. In 1924, the church added an addition to the north end. Later, an annex was added for educational and social purposes. In the late 1950s, an elementary classroom and lounge was added. The bell for the church came by train to Mechanicsburg. (Both, courtesy of Trindle Spring Lutheran Church.)

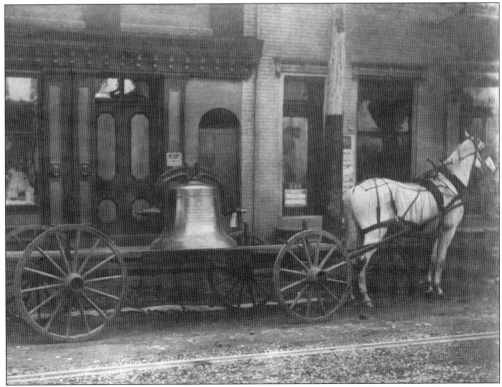

Among the 175 church members who attended a picnic at Willow Mill Park on July 24, 1939, were these members of the Trindle Spring Lutheran Church Young Ladies Sunday school class. Picnic attendees participated in a baseball game, a banana eating race, apple balancing, shoe scramble, girls bean race, boys bean race, chicken relay, and a cake walk. (Courtesy of Trindle Spring Lutheran Church.)

As reported in the *Harrisburg Telegraph* on September 18, 1915, the Young Men's Bible Class celebrated a growth of 25 members. Only four members were in the class the previous year. George W. Simmons taught the class. Among those in the second row are Clare Hopple, Fred Weber, and Samuel D. Basehore. (Courtesy of Trindle Spring Lutheran Church.)

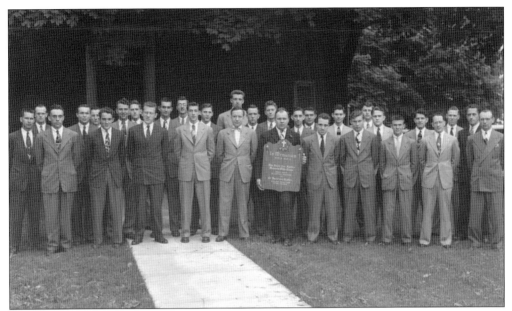

In the late 1940s, Trindle Spring Lutheran Church held a dedication for the Lt. David Lee Kistler Bible Class. In June 1944, Lieutenant Kistler's plane was shot down over Romania and he was reported missing. His body was later found and a memorial service was held in his honor in Romania, where he is buried. Lieutenant Kistler resided in Mechanicsburg and attended Trindle Spring Lutheran Church. (Courtesy of Trindle Spring Lutheran Church.)

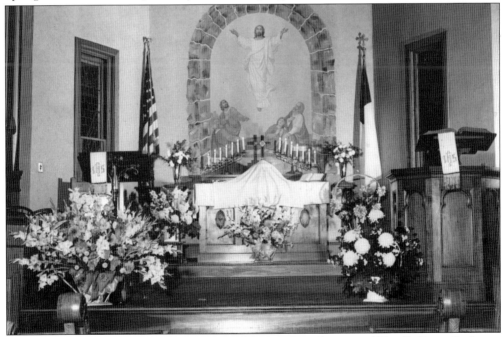

In 1993, a new sanctuary was dedicated across the street from the original Trindle Spring Lutheran Church. The sanctuary has the stained glass windows, altar, and pulpit from the original church. At the front is a painting of the ascension of Christ. The earlier church still stands. (Courtesy of Trindle Spring Lutheran Church.)

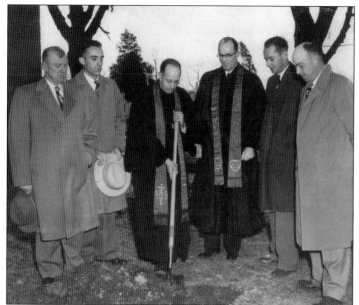

In 1951, a ground breaking ceremony took place for an educational annex and a social hall at the original Trindle Spring Lutheran Church. Today, social and educational events take place across the street from the original church in the 1993 educational building. Pictured here from left to right are S.D. Basehore, Wilbur Bucher, Rev. Charles I. Rowe, Rev. F. Putman (president of synod), Robert Weaver, and Willard Fought. (Courtesy of Trindle Spring Lutheran Church.)

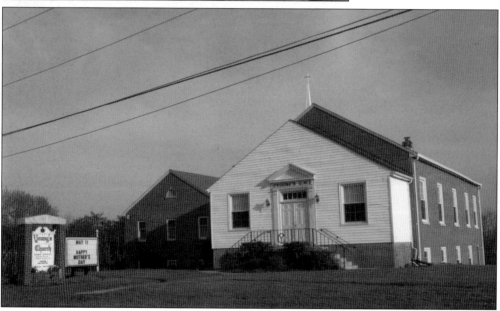

Located on Wertzville Road near the North Mountain is Young's United Methodist Church, formerly known as the Silver Spring Meeting House. Joseph Young Sr. deeded the land to the church, and the board of trustees erected the church house in 1843. Prior to the building of the church, worship took place in the form of camp meetings. From 1835 to 1843, an organization of pastors known as the Carlisle Circuit led the services. The church building has been enlarged four times. The first renovation took place in 1885, and two entrances were added—one for men and one for women. During the worship service, men sat on one side of the sanctuary and women sat on the other side. A partition separated them. During this time, it was considered a serious offense for the sexes to sit together during the church service. In 1914 the church was renovated again, giving it a single entrance. In 1968, the church went through another renovation. (Courtesy of Christine Clepper Musser.)

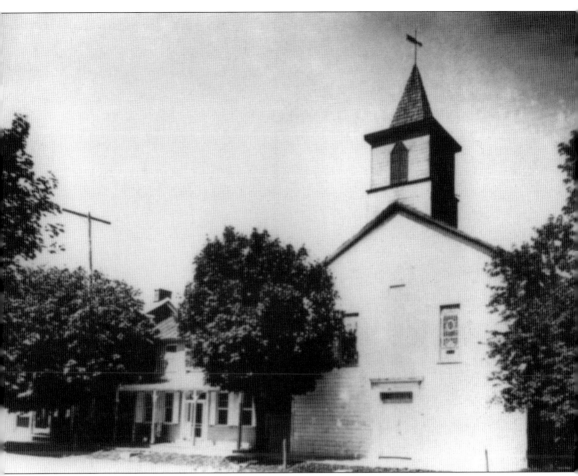

In 1865, what was first known as Mt. Zion Church, on the outskirts of New Kingstown, was moved within the borders of the village. The church structure was dedicated in 1866. This church served the community for 65 years. In 1930, the church shown in this photograph was demolished in order to build a new church. The bell and the weathervane were salvaged; both have been in service for almost 150 years. The stained glass windows from the 1921 church were transferred to the newly constructed 1930 church and again to the renovated 1951 church. The church was dedicated as Trinity Evangelical United Brethren Church on March 9, 1952. It is known today as the New Kingstown United Methodist Church. (Courtesy of New Kingstown Vision.)

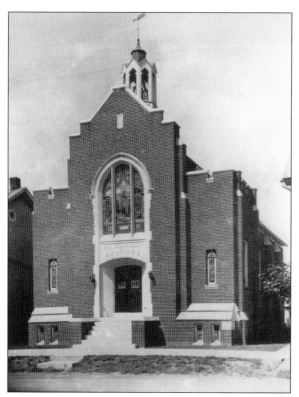

New Kingstown United Methodist Church, pictured here in 1930, has gone through many transitions over the years. Although the front has remained the same, additions to the church were made many years later, including an educational center on the left side and a parking area on the right. The sanctuary has a stained-glass window that depicts Christ embracing a shepherd. (Left, courtesy of New Kingstown Vision; below, courtesy of New Kingstown United Methodist Church.)

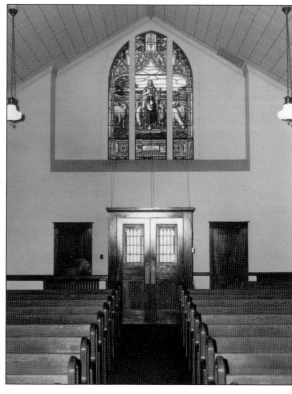

Four

SCHOOLS

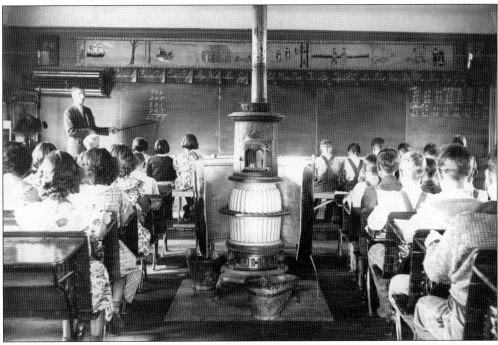

The Anderson one-room schoolhouse is located on Texaco Road in Mechanicsburg. Mr. Hair was the teacher in 1938 for students in first through eighth grade. A coal stove was in the center of the room bordered by desks and separating the girls from the boys. The students were arranged with the youngest in the front and the older students in the back. The desks were made of wood with cast iron legs. There was an opening in the desk for books. The class size varied depending on the population. In 1953, students who completed the eighth grade were sent to Cumberland Valley High School. The school ceased operation in the mid-1950s when Silver Spring Elementary School was built. (Courtesy of Cumberland County Historical Society.)

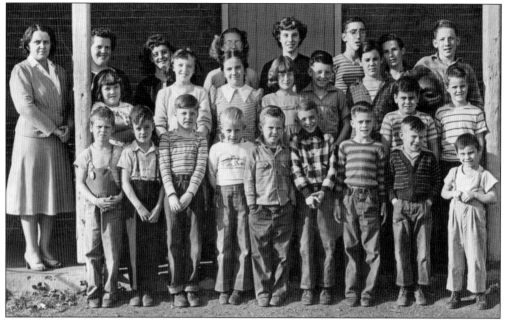

This photograph of the students at Trindle Spring School was taken in 1948. From left to right are (first row) Alfred Darbrow, Cletus Taylor, Bob DeSilra, John Failor, Art Fike, Clyde Weiser, John Swartz, and Spurgeon Darbrow; (second row) teacher Alverta Stoner, Nancy Gochenauer Hornberger, Jean Swartz, Loyal Wickard, Pat Swartz, Spenser Anderson, John Fike, Harold Coover, and Dan Fike; (third row) Ruth Wertz, Lizzie Butler, Arlene Orris, Francis DeSilra, Wilbur Lowery, Rudy Reese, and Paul Murphy. (Courtesy of Nancy Gochenauer Hornberger.)

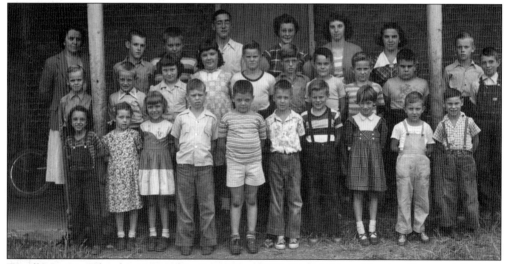

Trindle Spring School is pictured in September 1950. From left to right are (first row) Barbara Weiser, Judy Hershey, Mary Jane Fought, Alfred Durbrow, David Gochenauer, Terry Eckert, Sam Wertz, Barbara Enck, Clyde Gouse, and Spurgeon Durbrow; (second row) Guntus Steffers, John Failor, Marlene Staub, Nancy Gochenauer, Danny Fike, Robert DeSilvia, Bob Kimmel, Art Fike, Harold Coover, and Clyde Weiser; (third row) Alverta Stoner, Morris Steffers, Paul Heron, Wilbur Lowery, Geraldine Carlin, Francis DeSelvia, Loyal Wickard, and Ritas Steffers. (Courtesy of Nancy Gochenauer Hornberger.)

At the Trindle Spring School, students played tag and baseball and jumped rope during recess. Recesses were not guaranteed, except during lunch time. During inclement weather, students would stay inside and play jacks or board games. There was no indoor plumbing. Students had to use the outhouse, one for girls and one for boys. As a keepsake and recording of the students, class pictures were taken at the beginning of each school year. Among the students pictured in the 1953 photograph above are Clyde Weiser, Boyd Shepler, Don Failor, and Marlene Staub. Pictured below from left to right are (first row) Clyde Gouse, John Enck, George Smith, Nancy Kimmel, Vicky Wickard, and Venita Whitcomb; (second row) Bobby Mackey, Alfred Whitcomb, Dennis Wade, Spurgeon Darbrow, Barbara Weiser, Judy Hershey, Barbara Enck, and Joanne Shepler; (third row) Glenn Huff, Terry Eckert, and David Gochenauer. (Both, courtesy of Nancy Gochenauer Hornberger.)

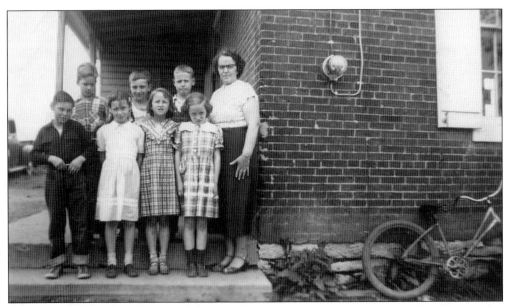

In this c. 1953 photograph, Harold Coover has his bike propped against the schoolhouse. This was his everyday bike that he rode to school. He had a bigger bike that he rode on sunny days or special occasions. The third grade students pictured here are, from left to right, (first row) Spurgeon Darbrow, Judy Hershey, Joanne Shepler, and Virginia Beamer; (second row) Dennis Wade, Clyde Gouse, and Alfred Whitcomb. (Courtesy of Nancy Gochenauer Hornberger.)

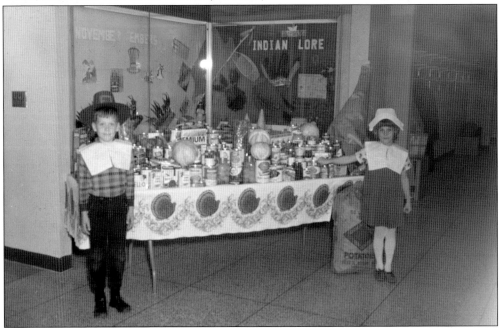

In recognition of Thanksgiving, Glen Garman and Alicia Kreamer from Green Ridge Elementary School stand beside a table of collected non-perishable items to be distributed to less fortunate families. Green Ridge Elementary was built in the mid-1950s as part of the Cumberland Valley Joint School System. The elementary school is located off Green Ridge Road, north of Hogestown. (Courtesy of Cumberland County Historical Society.)

The Hogestown School had two floors. The first floor was for students from first through fourth grade and the second floor was for fifth through eighth grade. During recess, students would visit the grocery store next to the school and purchase penny candy. Hogestown residents saved the school from burning to the ground in January 1918. A student saw smoke coming from a crack in the stovepipe and alerted a teacher. The teachers were commended on the way they removed the students from the school without incident. On October 15, 1954, Hurricane Hazel devastated the Northeast. The hurricane brought 98-mile-per-hour winds to the Cumberland Valley at 9:00 p.m. The high-powered storm took off part of the Hogestown School's roof and brought down trees, power lines, and telephone lines. (Above, courtesy of William Goetz III; left, courtesy of Elaine Humer Sweger.)

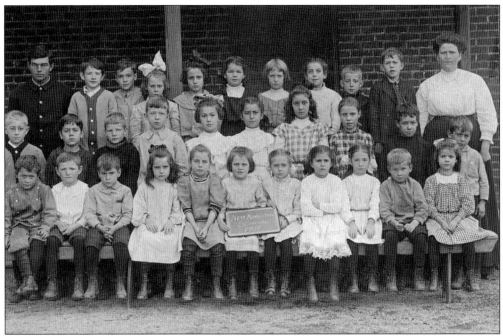

The New Kingstown Schoolhouse is located on West Main Street in New Kingstown. When students were sent to the book room as a punishment, they would climb out the window and go next door to purchase penny candy, unbeknownst to the teacher. In December 1940, a Yule party brought together 150 students who attended schools throughout Silver Spring Township at the New Kingstown School. (Both, courtesy of New Kingstown Vision.)

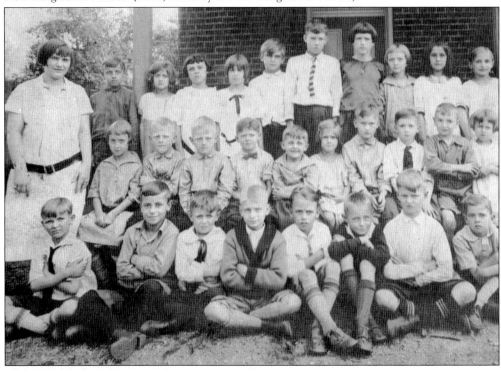

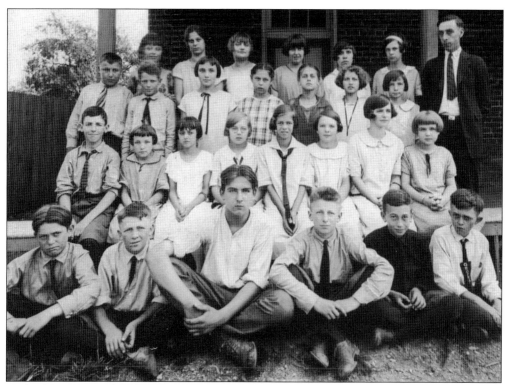

In the late summer, local newspapers listed the start day for each school, and the name of the teacher leading each classroom. Schools usually started after Labor Day. In the fall of 1908, a smallpox epidemic broke out in New Kingstown leading to quarantine. A guard house opened on East Street in Carlisle to house some of the quarantined, while others were quarantined at home. New Kingstown School closed for two weeks. According to Pennsylvania's education laws, one-room schoolhouses had to have at least 10 students attending the school. This was difficult at times for rural schools. (Both, courtesy of New Kingstown Vision.)

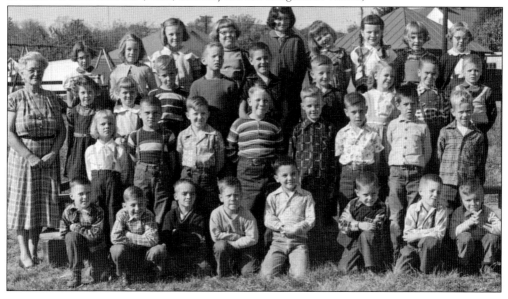

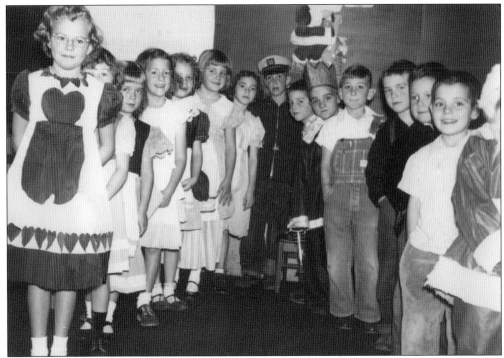

While attending New Kingstown School in the early 1950s, Mel Raudabaugh, sixth student from the front on the right, participated in a Christmas program. He was only five years old. By 1955, the New Kingstown one-room schoolhouse was closed and students were sent to Silver Spring Elementary School. (Courtesy of New Kingstown Vision.)

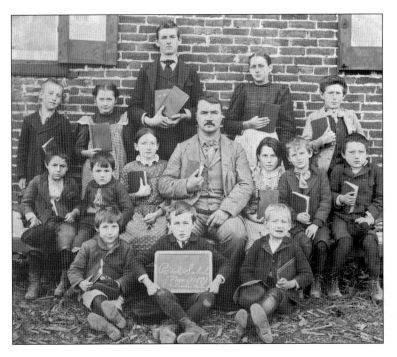

C. Herman Devenney was the teacher of the Pond School in 1897. The school was located on Timber Road off Locust Point Road and is no longer standing. Murray R. Whitcomb, a student at Pond School (standing in the center of the back row) went on to become a teacher at the Churchtown School. (Courtesy of Cumberland County Historical Society.)

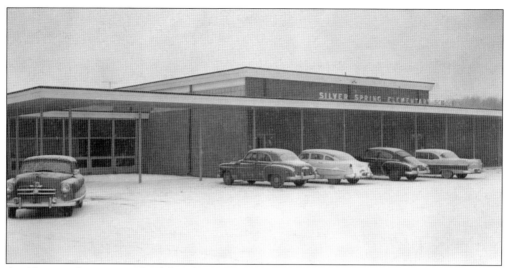

An 18-room elementary school for Silver Spring Township was completed in 1955 to replace eight one-room schoolhouses and Hogestown's two-room schoolhouse. The Silver Spring Elementary School is located on the hill above Cumberland Valley High School. In addition to the 18 classrooms, there was a multi-purpose room, kitchen, music room, and an office suite for faculty. Prior to the building of Silver Spring Elementary School in 1955, the secondary students were sent to one of five high schools. Today, the elementary school has 26 classrooms and a multi-purpose room that is used as a gymnasium. (Above, courtesy of Cumberland County Historical Society; courtesy of Sherry McDonald.)

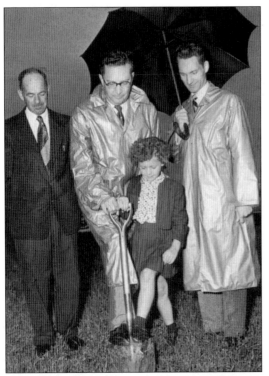

The Cumberland Valley School District was established in 1952 as the Cumberland Valley Joint System and included Hampden, Middlesex, Monroe, and Silver Spring Townships. Max C. Hempt donated the land to the school district. The Joint Committee broke ground in 1953 for the high school. The first year students attended the high school was 1954. Prior to that, secondary students attended the five nearby high schools. In August 1963, the school system became known as Cumberland Valley School District. The first graduating class that attended Cumberland Valley as a fully organized school district was the class of 1959. Gilmore Seavers, pictured below and holding the umbrella at left, became chief administrator for the school system in 1952. Seavers eventually went on to become the first dean at Shippensburg University, and later president. Pictured at left from left to right are Walter E. Basehore, chairman of the Joint Authority; Warren C. Matlack, president of the Joint Board; Jeanne Witmer, school student; and Seavers. (Both, courtesy of Cumberland Valley High School.)

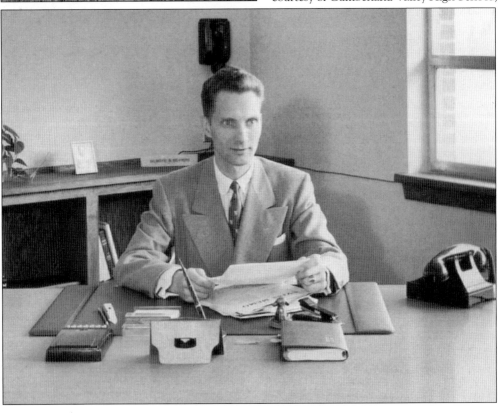

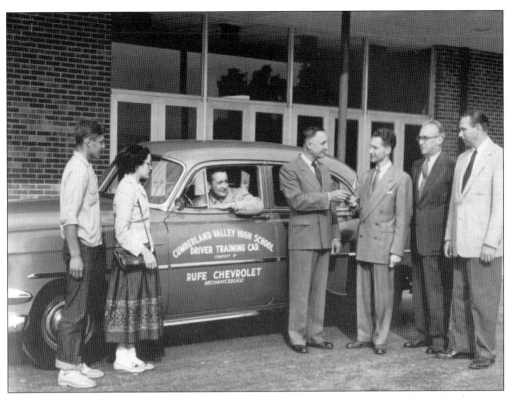

In 1954, Cumberland Valley High School got its first driver's-education car. Driver's education was an important part of the high school experience. Pictured here are Mr. Seavers, third from right, and the high school principal, Kenneth Whitney, far right. The education involved in-class lectures and tests, and eventually getting behind the wheel of a car while accompanied by the teacher. Before driving, a permit was required. (Courtesy of Cumberland Valley High School.)

The Sadie Hawkins Dance began at Cumberland Valley High School in the 1950s and was fashioned after the Lil' Abner comic strip. The event took place in November. Out of tradition, the females asked the males to be their date for the dance. The school cafeteria was decorated like Dogpatch, the cartoon town of Lil' Abner, with straw bales and corn shocks. Attendees would dress in jeans, pedal pushers, and button-down shirts. As part of the event, those in attendance would sign each other's shirts with their name and also a short note. (Courtesy of Cumberland Valley High School.)

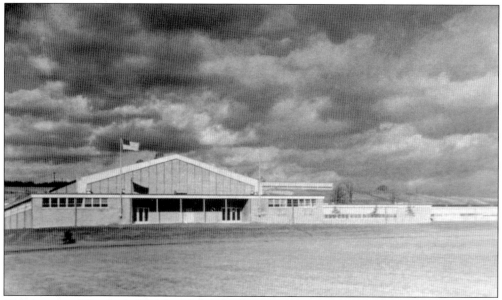

Construction of Cumberland Valley High School cost $1,935,000 in 1954. Gilmore Seavers organized the school curriculum and the doors opened on Tuesday, September 7, 1954. On November 19, the high school had its first open house. The structure was a one story building for grades seven through twelve. Enrollment for the 1954–1955 school year was 776. The postcard below was designed in 1955 after the building of Silver Spring Elementary School on the hill above the high school. Today, Eagle View Middle School is located on the same hill beside the elementary school. The Dapp farmhouse and barn still remain. Most of the farmland surrounding the schools has been developed or is in the process of development. (Above, courtesy of Cumberland Valley High School; below, courtesy of New Kingstown Vision.)

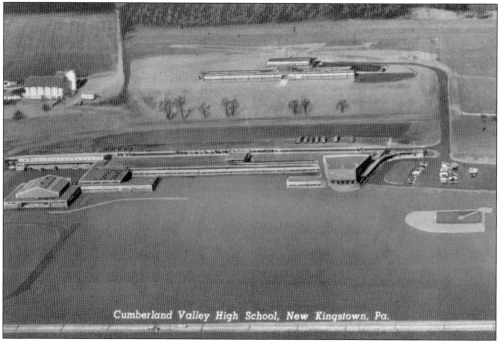

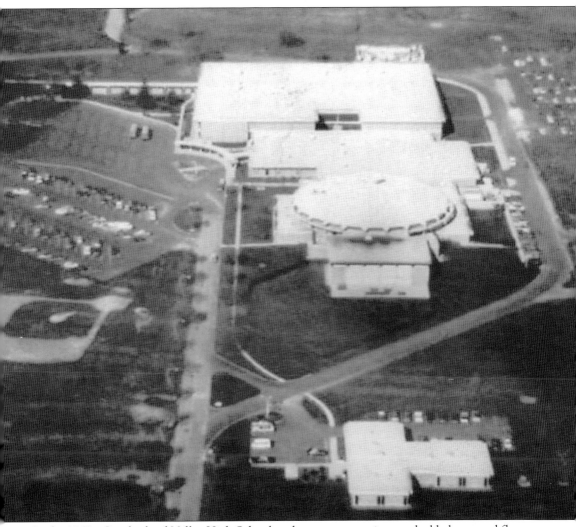

In the 1960s, Cumberland Valley High School underwent renovations and added a second floor. The school district continued to grow, and by 1968, school district administrators were looking at plans to build a new senior high school. On October 30, 1970, ground breaking for Cumberland Valley High School East took place. As part of the new construction a dome was added, which became an identifiable characteristic for the school. By the fall of 1972 the doors were officially opened to students, with William R. Pierce as principal. In the mid-1990s, Eagle View Middle School was built, eliminating the need for the original high school building. In the 21st century, the school district committed to another major building project. With the original high school gone, the district administrators had the capability of building a brand new high school. Today the high school is unrecognizable to students who attended prior to its 2002 construction. The "Dome" remains as the school's only identifiable feature to former students. (Courtesy of Cumberland Valley High School.)

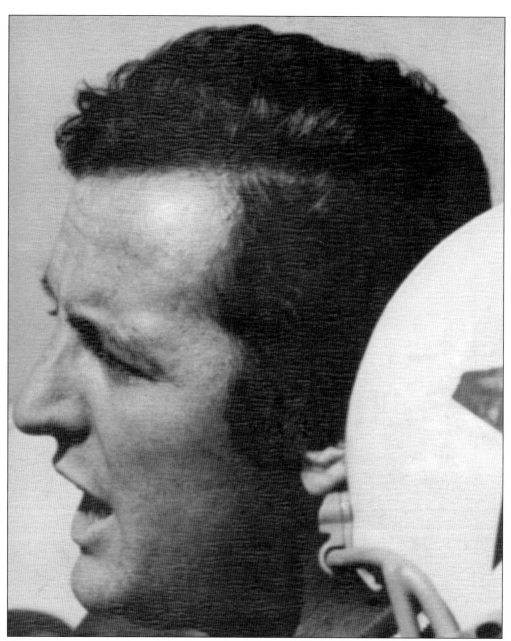

The winningest football coach for Cumberland Valley High School was Harry Chapman. Coach Chapman started at Cumberland Valley in 1971 as the varsity football and track coach and guidance counselor. He attended John Harris High School in Harrisburg and later joined the staff at John Harris prior to going to Cumberland Valley. Cumberland Valley varsity football ranked low when Chapman took the job, but in no time turned its rankings around. Coach Chapman had only two losing seasons in his 18 years at Cumberland Valley; his winning seasons came during his last 13 years as coach. While fighting bone cancer, Chapman still coached his team from a wheelchair. He also was the track coach during the last years of his life. Cancer eventually took him in 1989. He said, "A person shows what they are by what they do with what they have." (Courtesy of Cumberland Valley School District.)

Five

FARMING

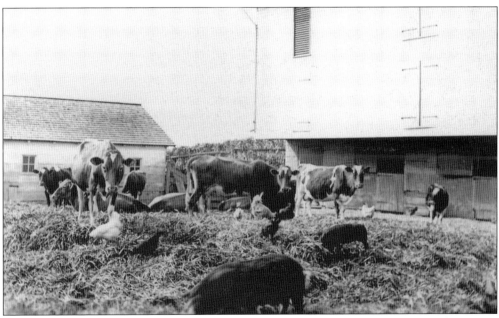

Farming has been an important occupation in Silver Spring Township since early settlement days. Settlers cleared the land of brush and trees, planted crops, and harvested them. Surplus crops were bartered or sold. Farmers took their crops or livestock by wagon to Philadelphia or Baltimore. Eventually the Cumberland Valley Railroad moved the products to their destinations. Before tractors, farmers used their own strength or that of a horse, mule, or oxen to work their land. As farming evolved, so did the farming implements. There were farms that specialized in raising pigs, sheep, chickens, turkeys, cattle, and produce. Each farm had its own required chores that included gathering eggs, milking cows twice a day, and feeding livestock. The planting season started in the spring and harvesting would begin in mid-summer and go to November. Often farmers worked together during the planting and harvesting seasons. Farm success depended on weather, insects, diseases, and prices for crops and livestock. (Courtesy of New Kingstown Vision.)

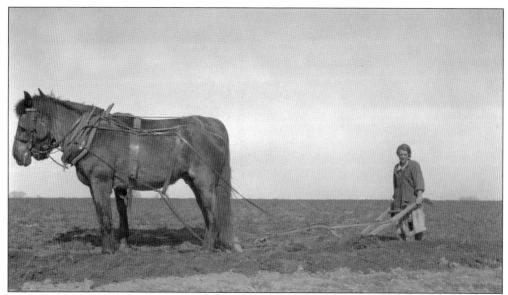

In the 1920s, Esther Zeigler was photographed plowing a field on her father Samuel's farm near Hogestown. Esther plowed the field with a two-horse walking plow pulled by two large mules. She kept the plow blade to the right, causing a deep narrow groove in the soil, also known as a furrow. This is where the seeds were planted. (Courtesy of Cumberland County Historical Society.)

"Cut your own firewood and it will warm you twice," said Henry Ford. Firewood had many purposes during the early years of Silver Spring Township. The wood was used to heat homes and cook stoves, or to make furniture, wooden bowls, or some other necessity or luxury. Wood was also used in limestone kilns. (Courtesy of New Kingstown Vision.)

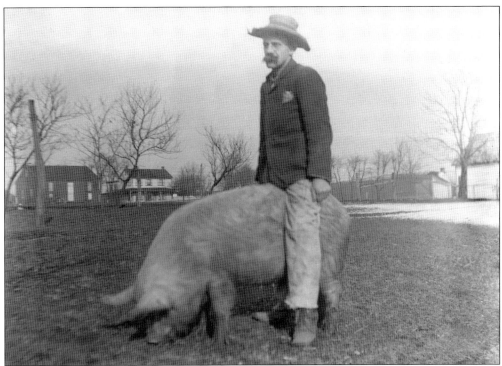

Swine breeds found in the Silver Spring Township area were Yorkshire, Berkshire, Chester White, and Poland China. Large pigs were popular in the township during the early 1900s. Silver Spring Township residents who received top placement at the Hogestown Stock Show were George W. Zeigler, Poland China; Sammuel Simmons, Berkshire; and George Messinger, Chester White. (Courtesy of New Kingstown Vision.)

Published in the *Harrisburg Telegraph* on December 24, 1898, was a little boy's Christmas list. On it he asked Santa for a goat cart. Children enjoyed being pulled around in a cart by a goat or two and that was the case in Silver Spring Township during the early 20th century. Goat carts were also used to haul produce. (Courtesy of New Kingstown Vision.)

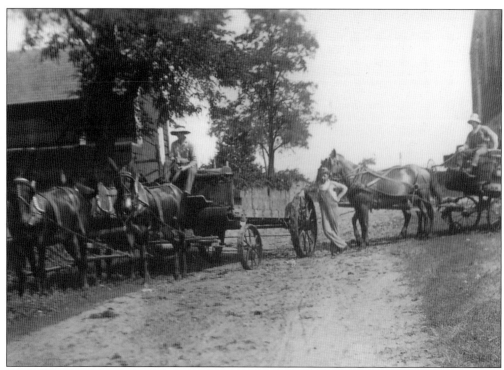

One of the dirtiest jobs on a farm is cleaning out the manure from a barnyard or stall. Before the mechanical manure loader, farmers and their helpers would have to load the manure onto a horse-drawn wagon with a pitchfork. The amount of time it took to thoroughly clean out an area depended on the manpower. Once the manure was loaded on the wagon, it would then be manually spread out with a pitchfork in a field. (Courtesy of New Kingstown Vision.)

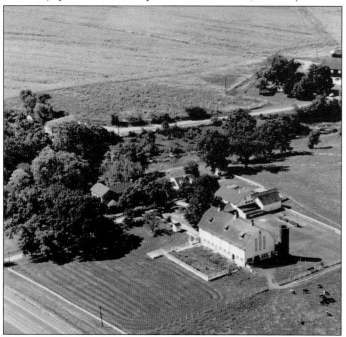

Shadow Oaks was owned by Sen. George Wade and later by his son, Dr. George Wade. The land was originally owned by John Hogue Jr. Hogue started the building of the estate, but passed away before its completion. It was finished by his daughter, Sarah. In 1937, a fire completely took the barn and in January 1938, friends of the senator came together and had a barn raising. The estate was named for the large white oaks on the grounds. Today the trees are gone, but the estate remains at the east end of Hogestown. (Courtesy of Betty Wade.)

Traditionally Monday was always laundry day on the farm, and before the washing machine, doing laundry was not an easy task. On the Wagner farm near the North Mountain, Annie Hoffman, pictured on the porch, situated her tub of water on the front porch and with a scrub board and lye soap scrubbed the dirt away. She hung the clothes on the clothes line to dry. Evora Rohland is in the foreground at right. (Courtesy of William Goetz III.)

Joseph Conrad's farm, located on the ridge north of Hogestown, was a stopping point for the milkman. Milk was picked up daily from farms and then taken to the milk plant to be bottled. Conrad, pictured at far right, was a prominent farmer in Silver Spring Township and a member of the Hogestown Grange, where he spoke on fire prevention in 1922. (Courtesy of William Goetz III.)

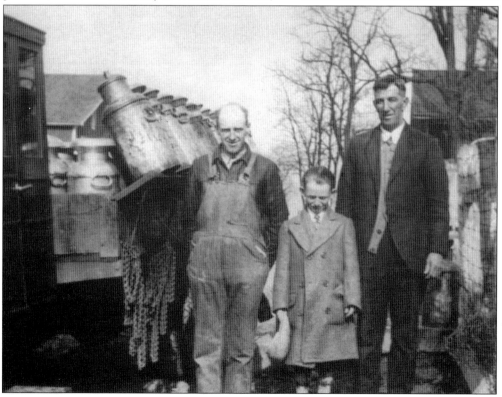

Draw kilns, also known as perpetual or running kilns, were sometimes found on farms. This particular kiln is located outside of Hogestown. Remnants of it still remain along Willow Mill Road. Silver Spring Township is rich in limestone, which was quarried by hand and loaded on a wagon. The stone was dumped into the top of the kiln, below which was a wood fire. The heat would draw the lime from the stone, causing the lime to fall to the bottom of the kiln. It would basically convert the stone to dust. The dust would then be collected and put into barrels. The lime would then be shipped to various masons and used for mortar. It was also used to fertilize the farmers' fields. (Courtesy of Gary Walters.)

Creeden Sunday was born in 1926 in New Kingstown, and his father, Clarence, later purchased the farm pictured here. The farm is no longer standing and is presently the location of Bonny Heights Homes. In addition to being crop farmers, the Sundays were also dairy farmers. There were approximately 20 Holsteins that needed to be milked by hand twice a day. As a youth, Sunday remembers having to pull the hay wagon up the barn hill in order to put the hay in the hay mound. This was not an easy task, especially on a hot and humid summer day. (Courtesy of Creeden Sunday.)

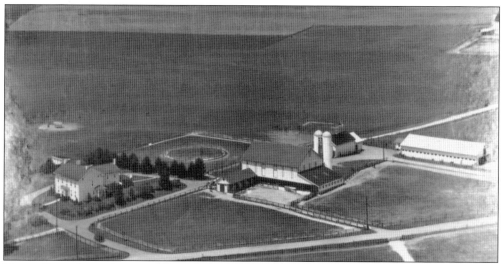

Hempt Farm, located across from Cumberland Valley High School, is a beautiful equine farm and landmark in Silver Spring Township. The farm was established in 1937 and remains in the Hempt family today. Max C. Hempt owned and bred champion Standardbreds, including Stenographer, a world champion and horse of the year in 1954. Hempt Farm was the location of the first experiment for a 3M Tartan track. (Courtesy of Max J. Hempt.)

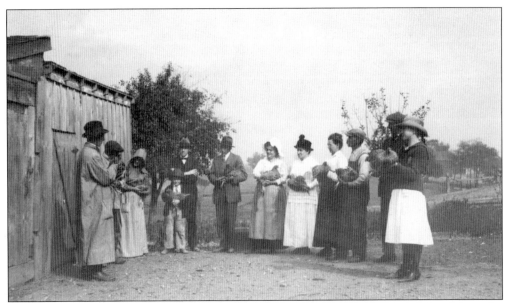

Renowned poultry specialist Paul R. Guldin from State College (far left) traveled throughout the state educating farmers and young people on poultry. On October 23, 1918, Guldin visited the Irvin C. Hummel farm near New Kingstown to discuss various breeds of poultry. The *Harrisburg Patriot-News* stated in its January 11, 1919, issue that egg prices were 32¢ a dozen and chickens sold for 40¢ to 60¢ a pound. (Courtesy of Cumberland County Historical Society.)

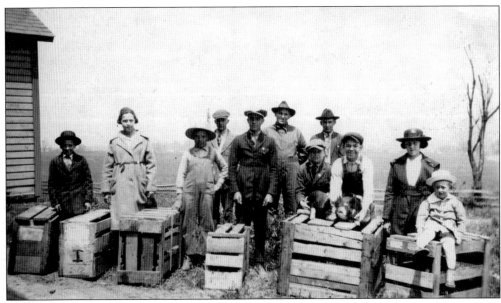

The Hogestown Berkshire Pig Breeding Club was established on April 26, 1921. Members raised young Berkshire pigs into healthy gilt for breeding. During the Hogestown Stock Show in June 1921, many of the young breeders won awards for their pigs. County Agent P.L. Edlinger led the group. Club members included Dale Ritter, Elmer Ritter, Willard Fought, Esther Zeigler, Robert Shuman, and Willis Kimmel. (Courtesy of the Cumberland County Historical Society.)

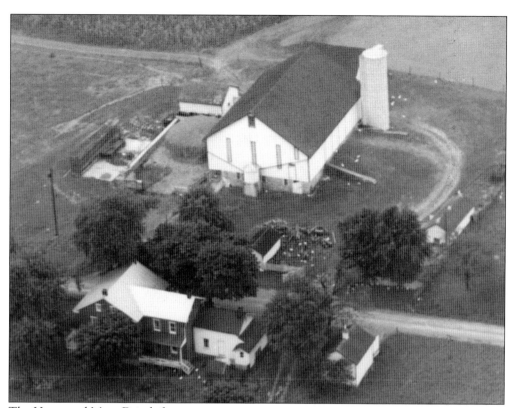

The Harry and Mary Deitch farm is the first farm in Silver Spring Township to enter into Cumberland County's Agricultural Conservation Easement Purchase Program, meaning that the land will be permanently preserved as farmland and will never go into development. Cumberland County farmland, particularly in Silver Spring Township, is considered prime fertile soil. In November 2013, township residents voted for a 1 percent tax increase permitting land preservation easements. Harry and Mary Deitch purchased their farm in 1946 and moved there on Easter Sunday 1947. Mary worked at a Mechanicsburg clothing factory until she and Harry were financially able to purchase cattle and farm machinery. The Deitch farm is a 128.44-acre crop farm. (Both, courtesy of Mary Deitch.)

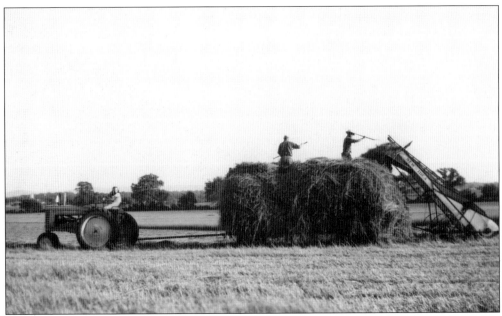

Mary Deitch worked alongside her husband doing farm work. She drove the John Deere tractor while her husband, Harry, and brother-in-law, Albert, loaded loose hay on the wagon on a hot summer day. Before the hay was gathered, it was mowed into rows allowing it to properly dry out. Gathering hay when dried out is important. Hay with moisture can cause spontaneous combustion and catch a barn on fire. However, if the hay is too dry, it will lose its nutrients. Another chore farmers had was gathering wheat and taking it to the barn for threshing. The tractor Harry Deitch used to transport wheat was a Row Crop 70 Oliver. (Courtesy of Mary Deitch.)

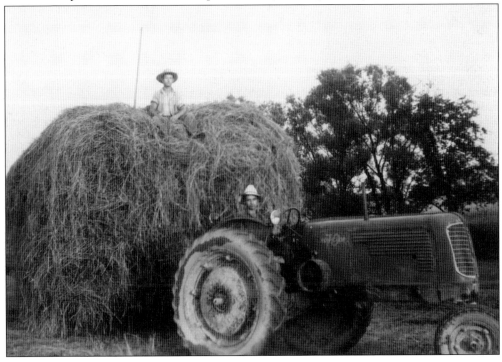

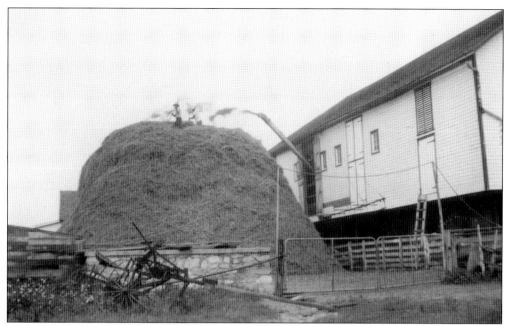

The invention of the threshing machine made processing wheat easier for farmers. Before the thresher, wheat had to be separated from the stalks by hand. On the Deitch farm, Harry Deitch took the wagon full of wheat to the second floor of the barn where the thresher was located and one of his helpers fed the shocks into the thresher, where the wheat was separated from the shock. The shocks were shot out of the barn to a wagon where Harry and his brother were waiting. (Courtesy of Mary Deitch.)

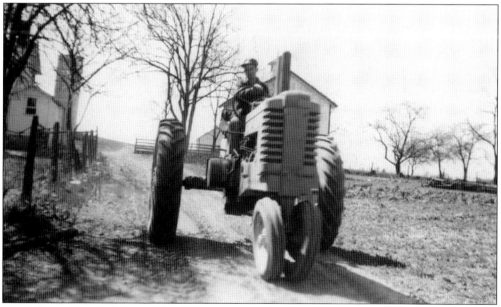

Here, Harry Deitch drives a John Deere tractor. John Deere was not the only tractor available to farmers in 1947. Massey Harris, International Harvester, Case, Oliver, Allis-Chalmers, and Minneapolis-Moline tractors were also available, but John Deere and International Harvester dominated sales. (Courtesy of Mary Deitch.)

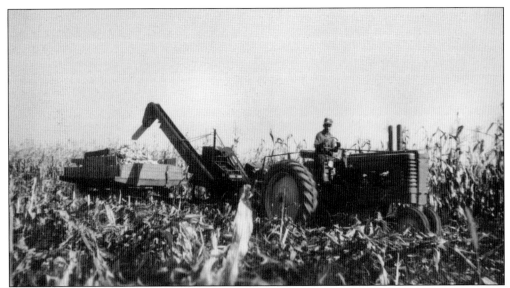

Corn was not always picked by machine. Initially, farmers and their helpers walked up and down rows of corn, picked the cob off the stalk, and threw it in a horse-drawn wagon. Children were sometimes taken out of school to help pick the corn. After the corn was picked, a metal husking hook or a small husking peg would be used to remove the husk from the ear. The corn then would be stored in a corncrib, where it would dry out. The invention of the corn picker helped farmers to work more efficiently. In this 1947 photograph, Harry Deitch picks corn with a corn picker. (Courtesy of Mary Deitch.)

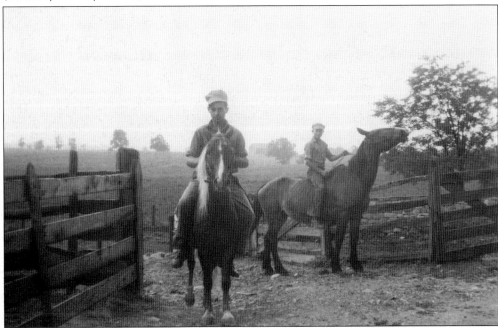

Harry Deitch (left) and his brother, Albert (right) found time to ride horses on their father's farm. The horses were a draft cross and a gaited pony mix. The draft cross is known to work the field and to pull wagons. The gaited ponies are smooth rides because they take high steps. (Courtesy of Mary Deitch.)

Harry Deitch's parents raised Guernsey cows. They are considered to be one of the best flavored milk producers and the milk is literally golden. It is high in protein and butterfat. Other farms in Silver Spring Township that produced award-winning Guernsey cows were Joseph Conrad, Vance McCormick, and Konhaus Farms. On September 13, 1932, the *Harrisburg Telegraph* ran an advertisement that read, "Golden Guernsey, America's Table Milk." (Courtesy of Mary Deitch.)

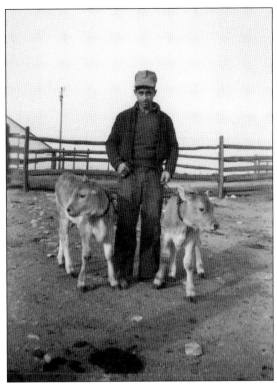

Lawrence Humer lived on the east end of Hogestown. In his backyard, he grew his own vegetables and raised chickens, which was not unusual for the time. Families who had the means to produce their own food saved money. Eggs were gathered from the chickens, and in the fall, the chickens could be butchered, giving the Humers food throughout the winter. (Courtesy of Elaine Humer Sweger.)

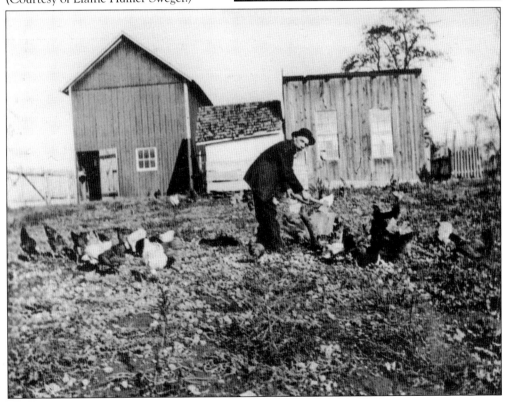

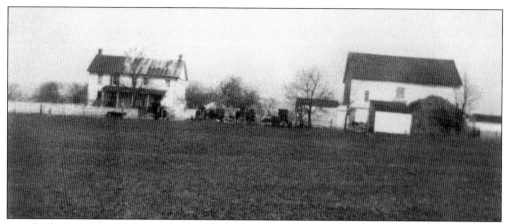

Joseph Clepper arrived in Silver Spring Township as a small boy in 1820. When he was old enough to do so, he purchased a farm next to the Mussleman farm near New Kingstown. In 1873, a wheat end became lodged in Clepper's throat and led to his death a few days later. His son, Joseph, eventually took over his father's farm. In March 1884, a tramp stole 18 pieces of meat from the Clepper farm and from a nearby farm owned by Mr. Sponsler. Once the men realized they were missing meat, Sponsler sent his dog to find the thief and the meat. The dog successfully located the thief and nine of the twelve hams. In 1889, a third Joseph Clepper was born and became an active participant in the Hogestown Stock Show. In 1907, he won an award for his three-year-old colt named Make Medium, and for a mule named General. In 1912, his horses came in first and second place. Joseph and his wife, Floetta, owned a farm along Willow Mill Road near Skyline Drive. There they had two children, Barbara and Joseph Merle. In 1920, the Cleppers sold their Silver Spring Township farm and moved to Hampden Township. (Both, courtesy of Christine Clepper Musser.)

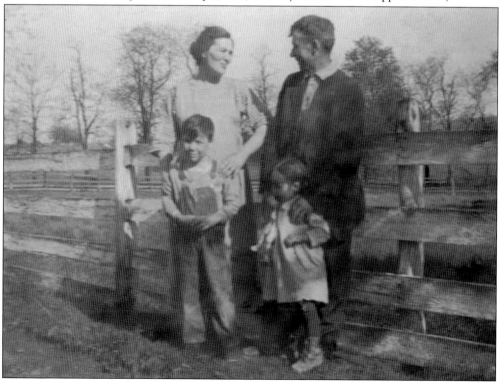

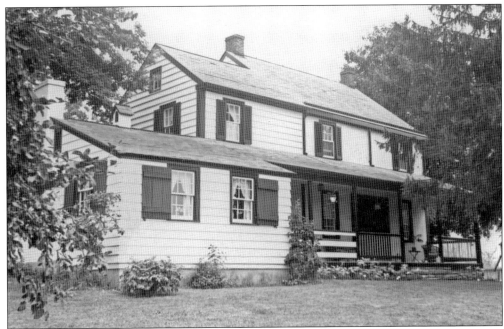

The McCormick farmhouse and barn were built in the early 1700s by Thomas McCormick, one of the township's original settlers. The land that McCormick claimed is located on the northeast end of Hogestown and stretches to the Conodoguinet Creek. During the French and Indian War, the Cumberland Valley was full of unrest. The settlers were annoyed with the Native Americans, and the Native Americans felt that the settlers had invaded their land. In 1757, William Walker (who owned property next to the McCormick property) and another man were killed by Native Americans. In 1805, the grandson of Thomas McCormick was killed in a farm accident, and for that reason, the farm was put into a trust to be used for farming only. (Both, courtesy of Dauphin County Historical Society.)

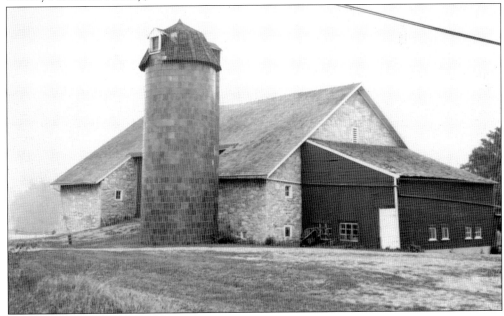

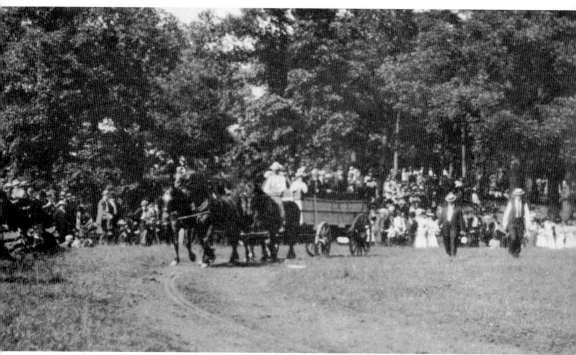

The Hogestown Stock Show began in June 1905 under the guidance of Vance McCormick, the Hogestown Farmers Club, and the McCormick Estate Farmers Club. In the beginning, the stock show only included farmers from the Susquehanna River to the Iron Bridge near New Kingstown. Eventually, anyone could participate in the show, but they had to pay an entry fee if they lived outside of Silver Spring Township. The show was held yearly at the Big Head Woods near Hogestown and usually ran for three days. Entries included pigs, cows, horses, mules, poultry, sheep, and goats. Women entered homemade butter and baked goods to be judged, and children and young adults participated by entering produce. During World War I, the show was closed in order for the farmers to support the national Man Behind the Plow campaign. The campaign slogan was, "The man behind the plow is the man behind the gun." The campaign goal was to produce as much product as possible to ship overseas. Although the stock show reopened in June 1919, it could not financially succeed. On June 8, 1922, the Hogestown Stock Show closed permanently. (Courtesy of Gary Walters.)

Six
BUSINESSES

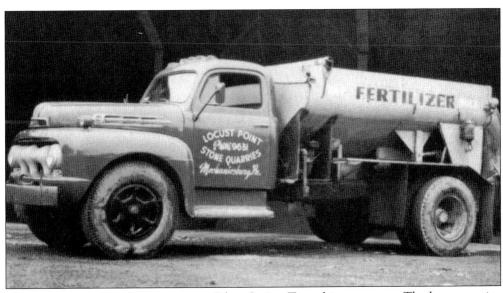

There are two active stone quarries in Silver Spring Township at present. The longest active quarry was started by Clyde Shaull, who owned the Locust Point Stone Quarry on Locust Point Road near New Kingstown. Shaull started his business in 1936 when funding came from the US government to build a turnpike from Carlisle to Pittsburgh. Locust Point Stone Quarry was awarded the project. After Shaull's death in 1949, Forrest Brenneman purchased the quarry. Twenty-six years later, the company was passed to Forrest Brenneman's son, Duke. Brenneman sold the quarry to Hempt Brothers in 1988, which continues to operate it today. Locust Point Stone Quarry started out as land owned by Clyde Shaull; because of its rock outcropping, Shaull seized the opportunity to start what proved to be a successful business. The quarry not only provided crushed stone for road work, but also agricultural limestone and fertilizer lime. (Courtesy of Cumberland Valley High School.)

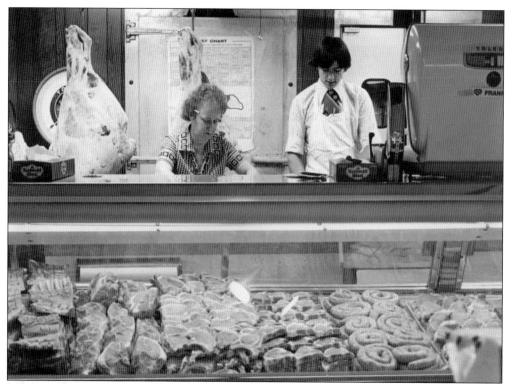

There were five Konhaus stores in the Harrisburg area. One was located in Silver Spring Township, as well as the turkey farm, with 60,000–80,000 turkeys and hundreds of acres of corn. There was a turkey processing plant, a state-of-the-art smoke house, and an industrial-sized kitchen where a wide array of foods were prepared for the deli and hot food departments of the store. The Konhaus stores offered full-sized butcher shops and scratch bakeries along with groceries. (Both, courtesy of Nancy Konhaus Griffie.)

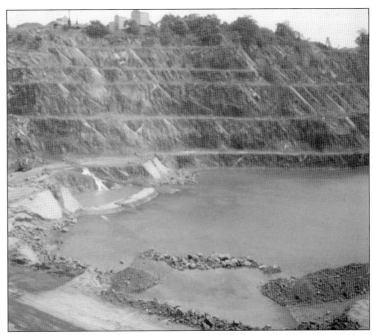

The second active stone quarry in Silver Spring Township is owned by Pennsy Supply, located behind present day Kohls and off Sample Bridge Road. The quarry was first opened in the 1950s by Fred Fiala. Under his ownership the quarry produced crushed stone. In 1962, Walter M. Mumma purchased the quarry from Fiala. Today the quarry is owned by Oldcastle Materials. (Courtesy of Pennsy Supply.)

Processing limestone begins with a geologist—once they determine that limestone is present, a permit is acquired and digging commences. The Silver Spring Stone Quarry received one of the first permits granted within Pennsylvania. Buildings were later added for dust control, a requirement from the Department of Environmental Protection. Limestone is used to make asphalt, concrete, blacktop, and crushed stone for construction. (Courtesy of Pennsy Supply.)

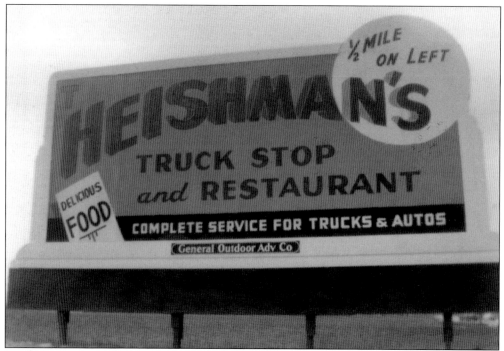

With the opening of the Pennsylvania Turnpike in Carlisle, truckers and travelers needed a place to get gas and vehicle repairs. In 1947, there were already a few service stations open, but the demand for more service stations grew because of the amount of traffic exiting the turnpike. Lafayette B. Heishman, fresh out of the Army, purchased land from Charles Sunday in 1946 to build a truck stop and restaurant on the east end of new Kingstown. To get the business up and running quickly, Heishman built a small concrete building for the station's office, with two Sunoco gas pumps in front. After the business opened in January 1947, Heishman added two service bays and a restaurant. Later, the Sunoco pumps were changed to Texaco. (Both, courtesy of Patty Heishman Moore.)

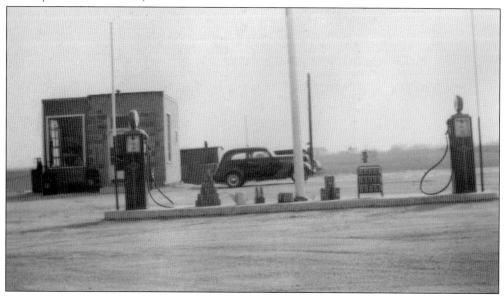

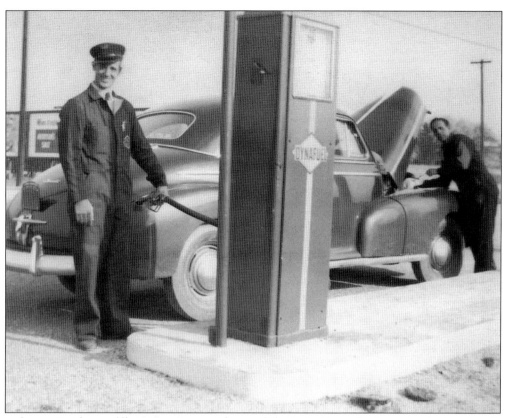

Lafayette Heishman fills a patron's car with gas while Ernie Gross checks under the hood. Full-service gas stations employed an attendant to come to the driver's window, ask them how much gas they would like, and pump the gas into the tank while the customer sat in their car. During this time, the attendant would also check the oil and clean the windshield and rear window. Full-service gas stations are very rare today. (Courtesy of Patty Heishman Moore.)

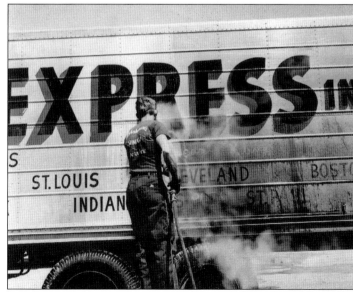

Truckers would roll in and trust their trucks to the Heishman crew. Here, a trailer is being power washed by one of the Heishman employees. The Pennsylvania Turnpike ran from Pittsburgh to Carlisle, which brought many truckers to Heishmans. During the winter, if the roads were impassable, truckers would park their rigs at Heishmans instead of venturing through the bad weather. (Courtesy of Patty Heishman Moore.)

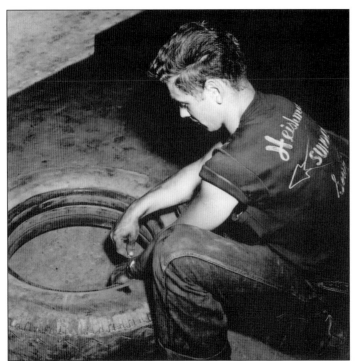

If a truck driver got stranded on the highway because of a damaged tire, a Heishman's mechanic would go to where the tractor trailer was sitting, remove the tire, and take it back to the garage to repair. When truckers needed to rest or if truck repairs took a day or so, they could shower and sleep in the 20-bed bunkroom. During the winter months when the roads were too treacherous to travel, the bunkroom would be full. Heishman also owned a fleet of tractor trailers. The drivers would haul steel for Youngstown Cartridge. (Both, courtesy of Patty Heishman Moore.)

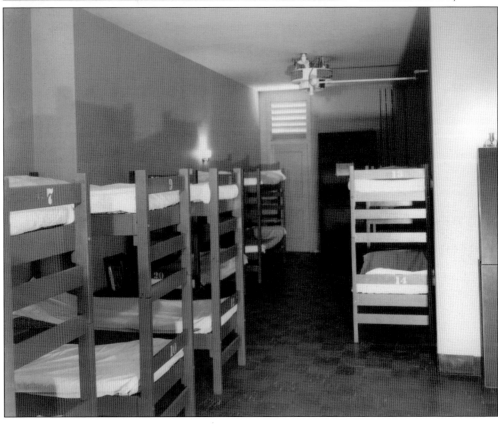

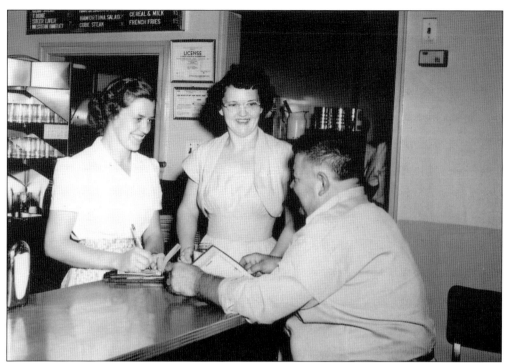

At Heishman's Restaurant, travelers and locals could find some of the best homemade cooking in the area. The menu included a daily feature; for example, Thursday's feature was chicken pot-pie. Other foods on the menu included macaroni supreme, baked chicken pie, ham and green beans, and baked chicken pie. Breakfast was served 24 hours. L.B. Heishman's wife, Mary, pictured at the end of the counter, seated the customers and Dottie Pottieger, one of the waitresses, pictured here taking a food order, served the food. (Courtesy of Patty Heishman Moore.)

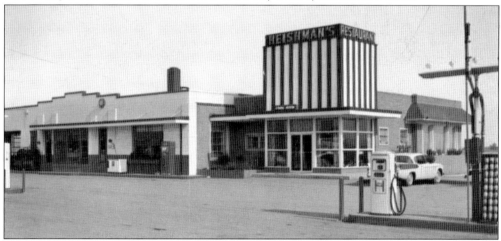

What started as a small concrete block building became a beautiful brick building where truck drivers felt so welcomed that during their vacations they would bring their whole family to eat at the restaurant and meet the Heishmans. The restaurant also offered a banquet room for Christmas parties, class reunions, and other special occasions. After 26 years, L.B. Heishman sold the ground and the business to Shaffer Trucking, which remains in Silver Spring Township today. (Courtesy of Patty Heishman Moore.)

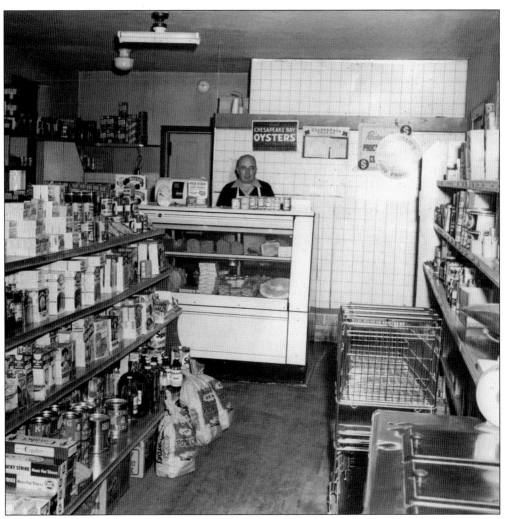

Located at 36 West Main Street in New Kingstown, Aunt Nellie's was a small grocery store owned by Melvin Raudabaugh. A few of the items sold in the store in 1948 were a one pound box of Nabisco premium crackers for 26¢, a large can of Silver Floss sauerkraut for 14¢, three bars of Fels-Naptha laundry soap for 26¢, a 16-ounce can of Hershey's chocolate syrup for 14¢, a pound of Swift smoked sausage for 59¢, one package of Charmin facial tissue for 21¢, and bubble gum for a penny. Gasoline could also be purchased at Aunt Nellie's. Raudabaugh owned the store until 1958, at which time it came under the ownership of Richard Defibaugh. In a 1979 newspaper photograph of the storefront, the gas pumps had been removed, and the store was Dye's Grocery. Today, the store is the New Kingstown Deli. The building that housed Aunt Nellie's was originally built on property purchased from Samuel Wonderly for the New Kingstown State Bank, which closed in 1926. (Courtesy of New Kingstown Vision.)

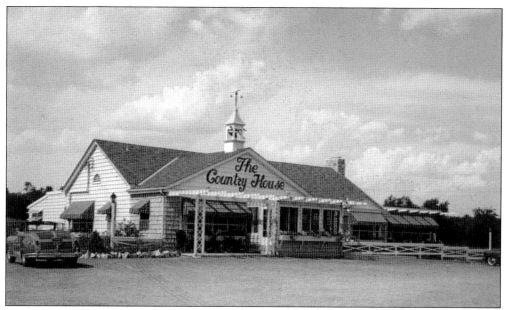

The Country House, located outside of New Kingstown along Route 11, was owned by Harvey Sunday and John Yinger. In the early 1950s, after his presidency, Pres. Harry Truman left his Missouri home on a road trip that took him as far as New York. During his trip, Bess Truman saw a beautifully landscaped restaurant where she wanted to stop. Harry and Bess stopped and entered the restaurant. At first, Truman was not recognized, but once he was, anyone who could showed up at the restaurant for a handshake or an autograph. The Trumans ate a fruit cup, which they said was the best fruit they ever had. (Courtesy of New Kingstown Vision.)

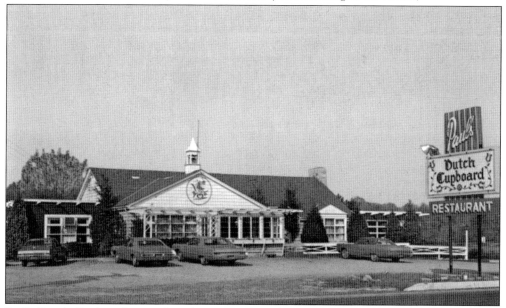

Paul's Dutch Cupboard opened in the 1970s after The Country House closed. The Cupboard, owned by Paul W. Charlton, had banquet facilities capable of handling business lunches and receptions. It was advertised as "quiet and restful; very good place to eat." (Courtesy of New Kingstown Vision.)

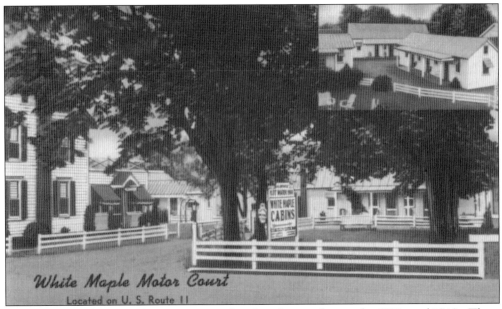

The White Maple Motor Court was a popular place for travelers in the 1930s and 1940s. There were 15 cottages available and seven guest rooms, with restaurants nearby. It was advertised as surrounded by shade with a cool lawn. Mr. and Mrs. Andrew Stewart owned the motor court. (Courtesy of New Kingstown Vision.)

The Trindle Spring Tavern was along the Trindle Road where present day Terranetti's Italian Bakery is located. The tavern was a popular stopping place for drovers moving cattle between Harrisburg and Carlisle. The Trindle Spring Tavern has also been known as the Sign of the Buck and Negley's Tavern. It was torn down in 1953 to widen Trindle Road. A few of the outbuildings remain today. (Courtesy of Trindle Spring Lutheran Church.)

Seven
AIRPORT

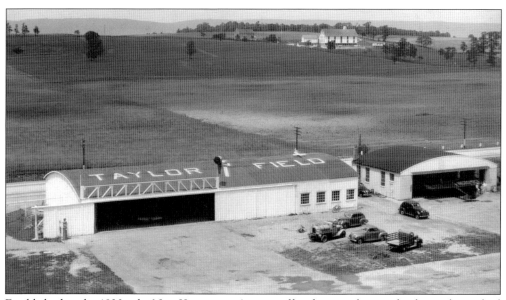

Established in the 1930s, the New Kingstown Airport offered private lessons for those who wished to become pilots. It offered airplane rides to visitors for a fee, and was a certified emergency-landing field. The airport was known by two other names besides the New Kingstown Airport: Wilson's Airport and Taylor Airport. On May 11, 1931, the *Harrisburg Telegraph* reported that due to a severe thunderstorm over the Harrisburg Airport, an eastbound plane had to land at the New Kingstown airfield. In 1936, grain was loaded onto an airplane and distributed to wild game over the snow-covered North Mountain bordering the Cumberland Valley. Postal Telegraph Cable Company poles lined the right side of the Carlisle Pike going east. An airport administrator contacted the Public Utility Commission (PUC) in 1941 and asked that the poles be moved to the other side of the street for safety reasons. Although the PUC ordered the poles to be moved as requested, they stated that it was only a temporary fix since the Carlisle Pike was a state highway. The annual model-airplane state championship was held at the New Kingstown Airport. (Courtesy of William Goetz III.)

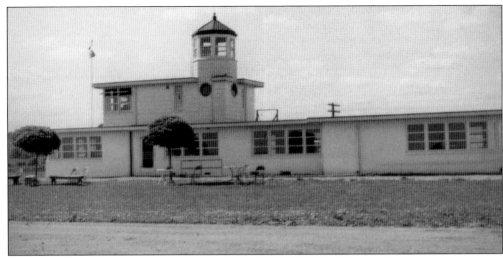

During World War II, Wilson Airport was used for Civilian Pilot Training (CPT). The trainees were required to enlist in the Army or Navy Reserves. The training gave those involved the opportunity to serve their country and to have a successful career as a pilot. The CPT program turned out 120 to 140 cadets a month. When W.F. Taylor went into the Army, he put 24-year-old Ethel Hart in charge of operations at Taylor Airport. Hart was responsible for a dozen Taylor-owned planes and eight privately owned planes kept at the field. In 1947, Hart filed charges against a 17-year-old who stole 329 three-cent stamps from Taylor Airport. Bill Goetz of Hogestown took flying instructions at the airport, and on his 16th birthday, he flew solo for the first time. First-time solo flights were always a big occasion at the airfield. (Both, courtesy of William Goetz III.)

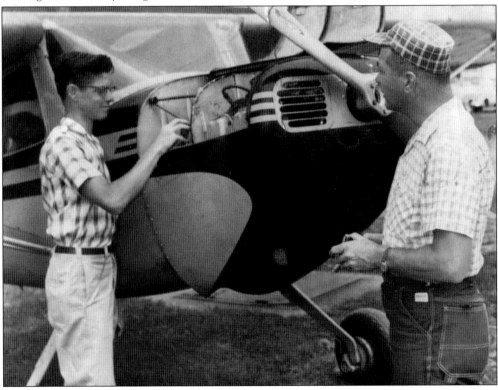

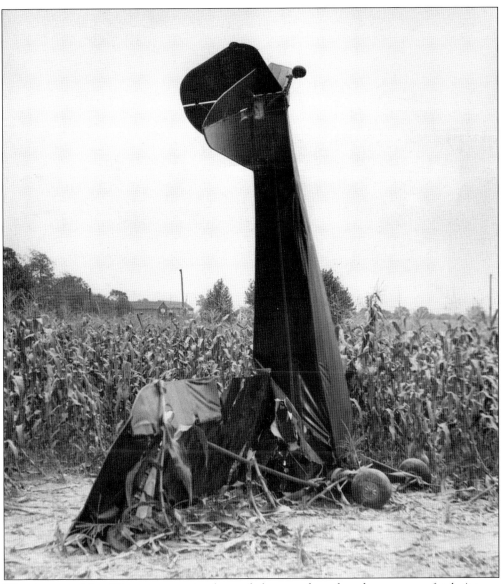
The airport at New Kingstown saw its share of plane crashes, though none were fatal. A two-passenger monoplane bound for Flushing, Long Island, left Wilson Airport on June 15, 1940. While flying over New York City, the plane began to run low on gas and had to make an emergency landing in Pelham Bay Park. The pilot and passenger were unharmed. In 1950, a Taylorcraft crashed in a cornfield behind the airport; the pilot survived. A local New Kingstown business filed an injunction against the owner and operator of the airport in 1944, citing that the planes flew too close to dwellings and endangered the residents of New Kingstown. Frank Wilson, flight instructor at the airport, was once forced to land his plane near Bridgeport, Pennsylvania, due to fog. (Courtesy of William Goetz III.)

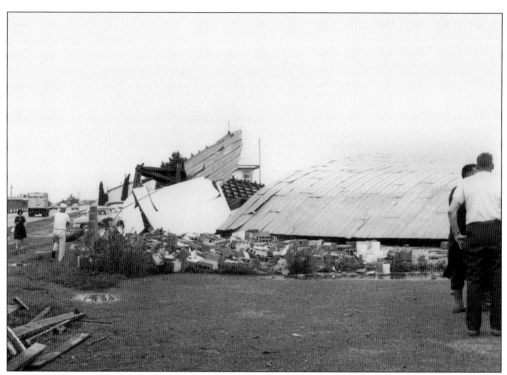

In July 1961, a storm hit the Cumberland Valley without warning. The storm took down trees and ripped roofs from buildings. The Taylor Airport's hangar was flattened, and the planes stored inside the hangar were destroyed. Planes that were sitting on the airfield were flipped, crushed, and torn apart. The storm put an end to the airport. (Both, courtesy of Steve Taylor.)

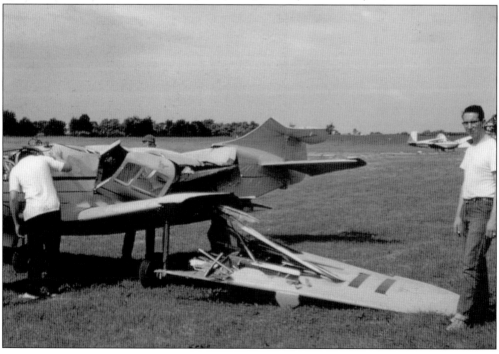

Eight
POST OFFICE AND FIRE COMPANIES

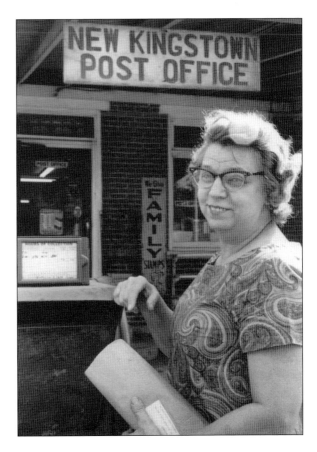

The New Kingstown Post Office was established in 1851. Post offices were usually located in general stores. Pictured here is postmaster Mary Defibaugh. Her husband ran the family grocery store, and Mary worked the post office in the back. Prior to the post office arriving in New Kingstown, the town name was spelled without the "w." The spelling of the village changed when the "w" was added in 1851, but the town was still referred to as New Kingston. The post office is now located on the east end of New Kingstown, where The Country House Restaurant and Paul's Dutch Cupboard were located. There is a 24-hour lobby with 600 post office boxes, the majority of which belong to truck drivers who pass through the town as they travel to and from the popular "Miracle Mile" in Middlesex Township, directly west of Silver Spring Township, which is a major hub for tractor trailers in the northeast corridor. (Courtesy of New Kingstown Vision.)

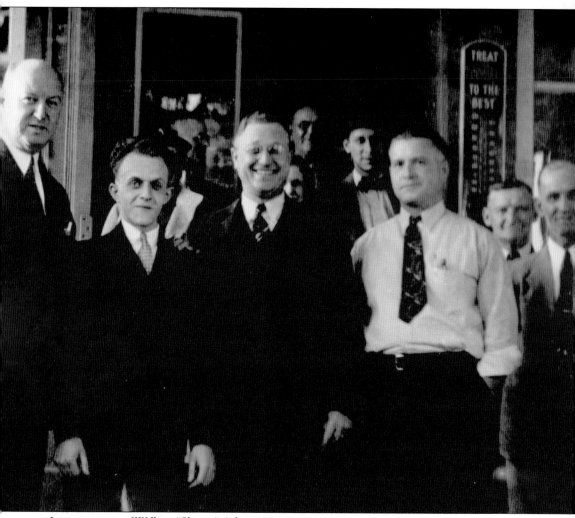

In recognition of Wilbert "Shorty" Adams, New Kingstown postmaster and the youngest postmaster ever installed in Pennsylvania, these postmasters met at the Harrisburg post office to celebrate. For years, the New Kingstown Post Office was located inside general stores and grocery stores in New Kingstown. (Courtesy of Ted Adams.)

In 1954 the Silver Spring Community Fire Department (SSCFD) was formed, making it the second fire department in Silver Spring Township. The first location of the fire department was on the grounds of the Silver Spring Speedway. In exchange for the use of the building, the fire department provided a fire truck and ambulance during the races. In 1958, SSCFD announced it would build a fire station along the Carlisle Pike next to Wayne's Garage. Ground breaking took place in May 1958, but the facility was not occupied until 1961. The volunteer firemen did all the construction themselves except for the blasting. They needed to raise $40,000 to help with construction. (Both, courtesy of Doug McDonald.)

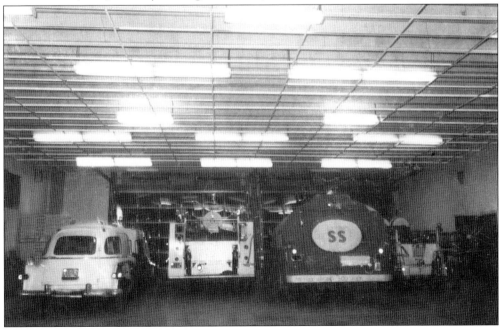

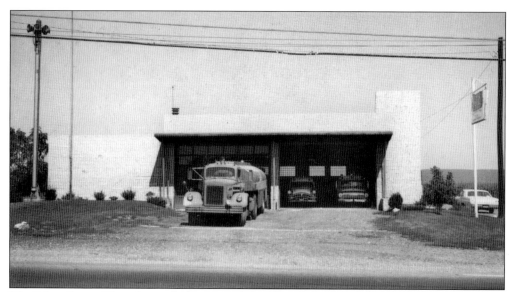

The Silver Spring Township ambulance was located at the Silver Spring Speedway in the 1950s. In 1970, the ambulance was moved to the same building as the Silver Spring Township fire trucks. It remained there until 1977, when it was moved to its own building on Eleanor Drive on land donated by Max C. Hempt. Silver Spring Community Fire Department eventually grew out of its building at 6506 Carlisle Pike and began construction on another building in 1994. In April 1995, SSCFD moved into its new building at 6471 Carlisle Pike. The building has five bays and a large banquet facility where bingo is played. (Both, courtesy of Doug McDonald.)

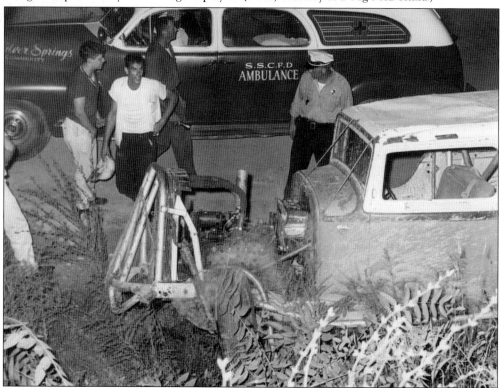

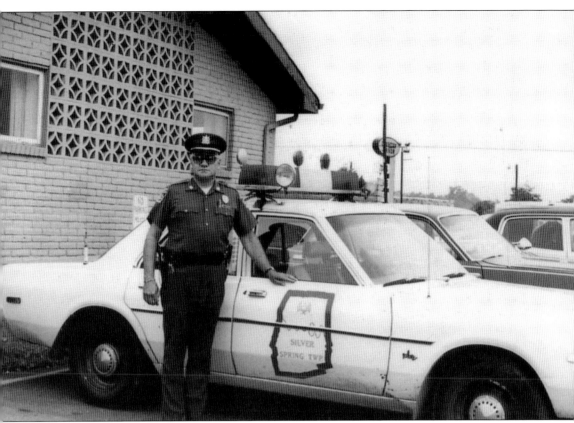

Silver Spring Township did not have its own police department until 1969. The Pennsylvania State Police had jurisdiction over the township. At this time, the township was mostly rural, and the Carlisle Pike did not have a traffic light, which led to many traffic accidents. There were also many bars and taverns, which gave the opportunity for drunken brawls and disorderly conduct. Trying to maintain peace within the township became overwhelming for the state police since they also patrolled much of Cumberland County. William Spaulding became the first chief of police for Silver Spring Township. John H. Toomey, pictured here, became the township's second chief of police and remained in the position for 25 years, retiring at the age of 72. Today, the township's police department has a canine team, a full-time school rescue officer assigned to Cumberland Valley High School, and officers assigned to the Cumberland County Accident Investigation Team and the Cumberland County Drug Force Team. The Silver Spring Township Police Department is located next to the township's administrative offices on Willow Mill Road. (Courtesy of Silver Spring Township Police Department)

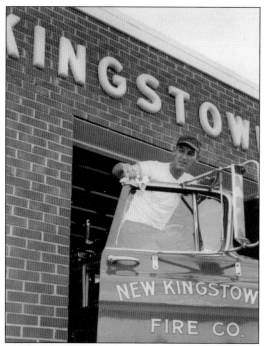

At 5:00 p.m. on July 15, 1911, a fire started in the stable of George Reed, on the west end of New Kingstown. Five houses, seven stables, and other buildings including St. Stephen Evangelical Lutheran Church were lost, as well as some livestock. Because there were no fire companies in the village at that time, establishing one became a top priority. On July 20, 1912, the New Kingstown firehouse was dedicated, Silver Spring Township's first fire station. In March 1912, the department received its first chemical engine, which could be pulled either by hand or by horses. Two 35-gallon chemical tanks, two small chemical extinguishers, and a 200-foot hose were mounted on the side of engine. Pictured here is Donald Grove. (Courtesy of Jim Hall.)

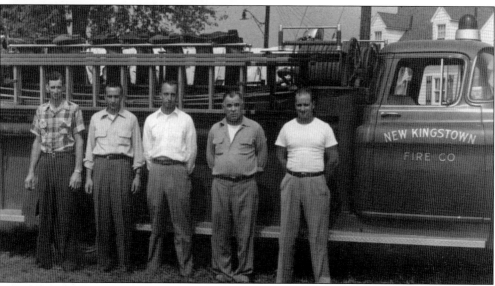

Both the New Kingstown Fire Department and the Silver Spring Community Fire Department are completely made up of volunteers. Their funding once came from money raised from fairs and community meals. Today, fire tax helps to fund the operational costs of both fire departments. The firemen had to be very creative when it came to stewardship. They purchased a 1936 Chevy cattle truck and turned the body into a chemical tank. They mounted the old chemical tanks from the first apparatus they purchased onto the rebuilt engine and added a 200-gallon booster tank and a 300-gallons-per-minute portable pump. Eventually, a 500-gallons-per-minute front-mounted pump, a 500-gallon booster tank, and a 35-foot wooden ladder were added to the apparatus. Pictured from left to right are Glen Yohn, Richard Raudabaugh, Hen Yohn, Lee Brenizer, and Luther Yohn. (Courtesy of Jim Hall.)

Nine
RECREATION

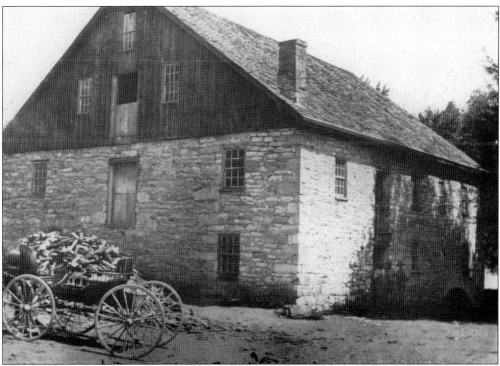

The Houston (Huston) Mill is located along the Conodoguinet Creek near Hogestown and was built in the late 1700s by John Walker. The mill wheel was powered by the Conodoguinet Creek at the mill race, a channel that runs the water to turn the wheel, driving the machinery. The mill was eventually transferred to several owners throughout the 19th century. It became known as Willow Mill (because of the willow trees) and became the property of Raymond DeWalt, who turned the property into a resort. Who changed the name of the property to Willow Mill and when is not known. (Courtesy of Dolly Hupper Berkheimer.)

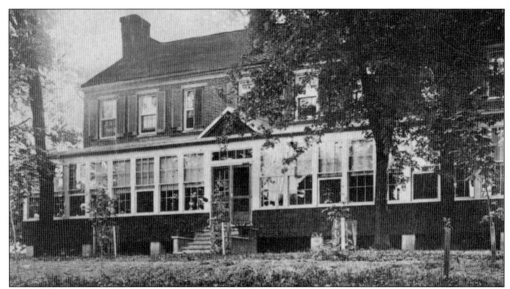

In 1929, Raymond DeWalt partnered with George Messinger to purchase the 200-acre farm and gristmill. In the 1930s and 1940s, visitors could stay and dine in the 20-room inn managed by the Messingers, which also had 12 fireplaces. Senator Booker, a wealthy man from Virginia, built the structure as his summer home. The DeWalts lived here year-round and ran the farm that was also on the property. Pictured is the Willow Mill Inn, where visitors to Willow Mill Park could stay and dine. (Courtesy of Dolly Hupper Berkheimer.)

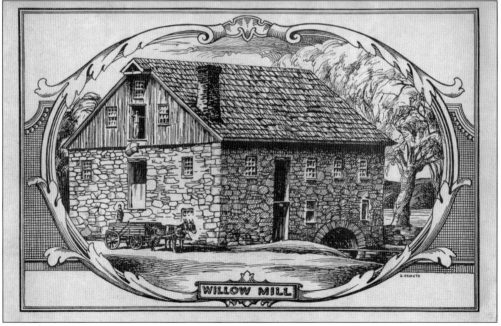

Willow Mill Inn Restaurant's menu cover featured a sketch of the historic mill. The mill would grind the corn used for muffins, corn meal, and old fashioned corn meal mush. DeWalt, who personally embraced a Rosicrucian philosophy, operated the inn as a haven to promote self-improvement through healthy living, natural foods, and introspection. (Courtesy of Dolly Hupper Berkheimer.)

The Willow Mill Inn was considered a place for fine dining. The favorite dish was the chicken and waffles. Broiled steak, salad or soup, mashed potatoes, two vegetables, coffee, and dessert cost $2.50. Other items included ham dinners and leg of lamb. If patrons were on a special diet, they could consult with the cook and have something specially made for them. For the health conscious, meatless entrees were also on the menu and cost $1.25. The majority of food items came from the Willow Mill farm. (Courtesy of Dolly Hupper Berkheimer.)

WILLOW MILL INN MENU

John C. Cake — Your Host
Kathryn Cake — Your Hostess

$2.50
Fruit Cup – Soup
Relish – Celery – Olives
Broiled Steak
Mashed Potatoes – Two Vegetables
One Leafy Green
Willow Mill Special Salad
Choice of Deserts
Coffee — Nuts

$2.00
Fruit Cup – Soup – Celery – Olives
Roast Chicken
with rich brown gravy
Mashed Potatoes
Two Vegetables – One leafy green
Willow Mill Special Salad
Ice Cream — Cake
Coffee — Nuts

$1.50
Fruit Cup – Soup – Relish
Country Style Fried Chicken
Potatoes Mashed
or
Willow Mill Style
Two Vegetables
Combination Salad
Desert — Coffee

$1.00
Willow Mill Country Dinner
Home Grown Ham
Sugar cured and hickory smoked
Served Country Style
With all that goes with a real
Country Meal
(Leave the Menu to Mother you'll like it)

$1.00
Soup — Relish
Creamed Chicken — Waffles — One Vegetable
One Leafy Green — Coffee

$1.25
Willow Mill Meatless Health Menu
Fruit served one-half hour before or after meal
Soup — Celery — Olives
Eggs — Fish — Nut Roast — Dried Legumes or Dairy Products
Two Vegetables — One Leafy Green
Salad with Mayonaise — Whole Wheat Bread or Muffins
Beverly Hall Cereal Coffee — Ovaltine or Willow Mill Milk
Honey or Brown Sugar Sweetening
Meats substitutes may be had in any Menu in place of meat or fowl regardless of price

Waffles, Butter and Honey 35c

DESERTS
Pie	10c
Pudding	10c
Pie a la Mode	20c
Cake	10c

SALADS
Crab	75c
Lobster	75c
Shrimp	60c
Tuna	60c
Chicken	75c
Fruit	50c
Egg and Lettuce	40c
Lettuce and Tomato	40c
Potato Salad	35c

SANDWICHES
Chicken	30c
Cheese	15c
Ham and Cheese	25c
Ham and Lettuce	25c
Willow Mill Special	20c
Tomato and Lettuce	20c
Egg and Lettuce	20c

BEVERAGES
Coffee, Tea, Chocolate, Postum or Beverly Hall Cereal	10c
Lemonade	10c
Orangeade	15c
Ginger Ale	35c
Orange Juice	20c

An elegantly set table at the Willow Mill Inn Restaurant is pictured here. The main dining area was in the center of the inn, but rooms could be portioned off for special occasions. (Courtesy of Dolly Hupper Berkheimer.)

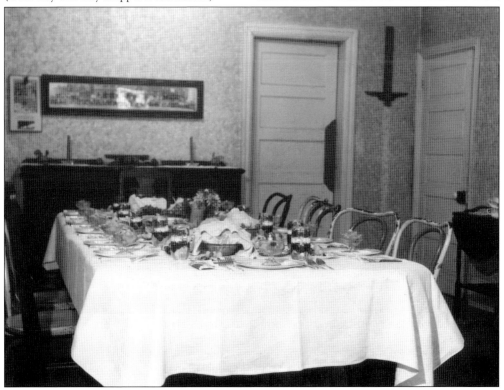

Vera Hupper, daughter of Raymond DeWalt and mother of Dorothy Hupper Berkheimer, describes the first time she saw Willow Mill Park. It was winter, and she wrote, "As we walked around the creek the evergreens glistening with ice lent a magic to the spot which never disappeared from me." (Courtesy of Dolly Hupper Berkheimer.)

As an amenity to the resort the area along the creek was developed as a park for the purpose of recreation, including swimming and canoeing. Visitors would travel from all over to Willow Mill Park. In later years, local newspapers mentioned on a regular basis various gatherings such as church picnics, business employee picnics, family reunions, and school picnics being held at the park. (Courtesy of Dolly Hupper Berkheimer.)

Raymond DeWalt had a vision of how he wanted the park to be. He described it as an ideal area for picnics and invited people to take naps on the grassy sward. There were tables to sit at for visitors who did not want to sit on the ground, swings and seesaws for children, and swimming in the Conodoguinet. DeWalt wrote poetry, and in his poem "Willow Mill Farm," he describes how he sees the farm and the park and attributes his improved health to Willow Mill Farm, describing how his heart overflows and how he has no woes. (Courtesy of Dolly Hupper Berkheimer.)

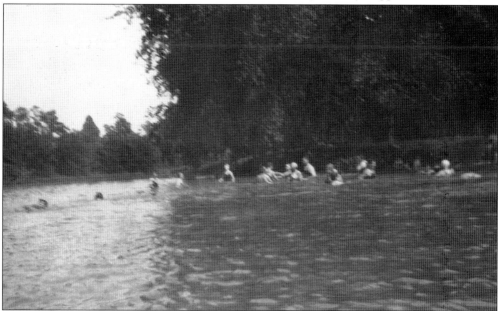

A popular swimming area at Willow Mill was the mill race. The mill race has since disappeared along with the Huston Mill's inner machinery, the dam, and the covered bridge that connected the north and south banks of the Conodoguinet Creek. The mill remains today, and a local group, Friends of Willow Mill, is working to restore it. (Courtesy of Dolly Hupper Berkheimer.)

Boating and fishing were two of the more relaxing activities on the Conodoguinet. During the summer months, the park was full of visitors both from the local area and afar. Raymond DeWalt built several cabins on the property for people who wanted to vacation at the park. During the winter, the creek would freeze over and turn into an ice-skating rink. (Courtesy of Dolly Hupper Berkheimer.)

Raymond DeWalt eventually leased the land to Aaron Runk, who developed it into an amusement park. In the late 1940s, Marilyn Stoner Swartz's father purchased the park from Runk and took over Willow Mill Amusement Park. On the grounds were a small pavilion and a machine shop where supplies such as paint were kept. There was also a roller skating rink in the park that Aaron Runk built. The rink burned down in September 1951. (Courtesy of Marilyn Stoner Swartz.)

Playland, better known as the Penny Arcade, was managed by William Bush. Inside, visitors to the park took chances on mechanical games that cost a penny, nickel, dime, or quarter. Also for enjoyment there was a fortune teller machine. Game winners received tickets and saved them for cash prizes. (Courtesy of Marilyn Stoner Swartz.)

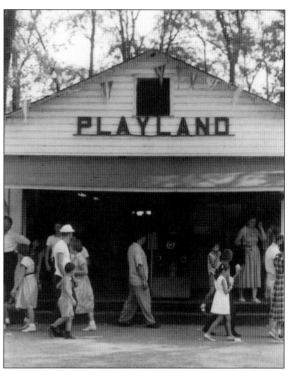

Every amusement park sells cotton candy, originally called "Fairy Floss." The cotton-candy machine was first introduced in 1904 at the St. Louis World's Fair, where approximately 68,655 boxes were sold at 25¢ each. Cotton candy is made by caramelizing sugar through spinning it on a rotating heated plate. In 1949, Gold Medal Products launched the cotton-candy machine. This cotton-candy stand was managed by Charles Crumlich. (Courtesy of Marilyn Stoner Swartz.)

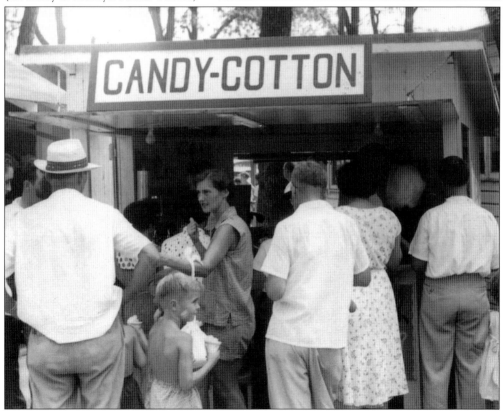

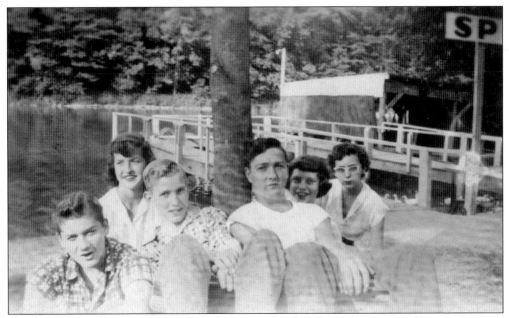

Many of the employees of Willow Mill Park were the friends of the owners' children. Pictured while taking a break are Marlin Swartz, Josie Crumlich, Robert Stauffer, Marilyn Stoner Swartz, Robert Maxwell, and Elaine Martin. (Courtesy of Marilyn Stoner Swartz.)

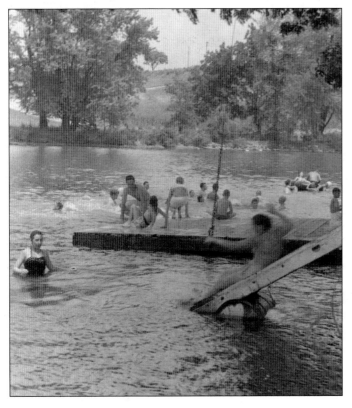

The Conodoquinet Creek was also known as the "swimming pool" at Willow Mill Park. The water was clear, and warm in the summer. Swimmers would take turns going down the water slide into the creek and jump into the creek from a wooden raft, as pictured here. Near the slide were steps like a swimming pool that led into the water. The depth at the beginning of the steps was about three feet, and as swimmers went further into the water the steps gradually leveled off at eight feet deep, which was deep enough for diving. Swimming was a popular event at the park especially on hot and humid days. (Courtesy of Marilyn Stoner Swartz.)

The most popular ride at the park next to the Speed Boat was the Blue Streak roller coaster. The Blue Streak treated riders to a fast ride around the creek. Some riders were daring and stood when the coaster went down the steep hill. In 1960, the name of the coaster changed to the Red Streak. (Courtesy of Marilyn Stoner Swartz.)

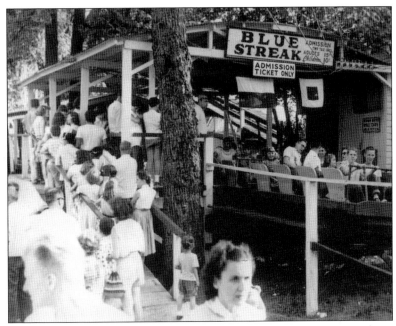

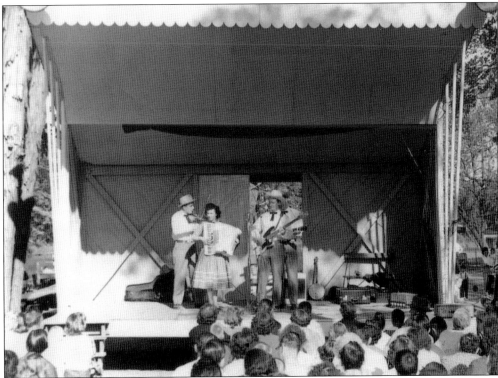

Entertainment was a large draw at the park. Here the Sons of the Pioneers are performing. Besides Country and Western bands, other entertainment included a Junior Miss Central Pennsylvania Pageant, magicians, and a talent show. Hot air balloon rides were also available. The entertainment shows took place mainly on Sunday afternoons and every so often on Saturdays. (Courtesy of Marilyn Stoner Swartz.)

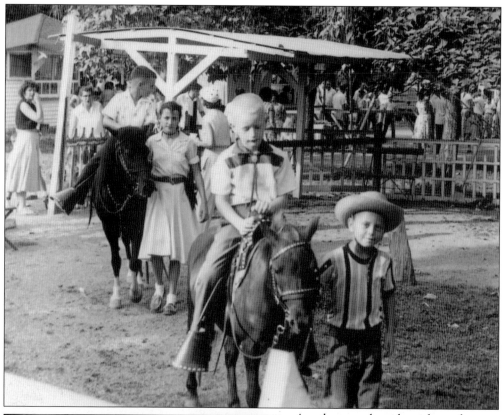

Another popular ride at the park was the pony ride. The boy leading the pony in the front is Merle Crumlich, and the girl leading the black pony, named Duke, is Bonnie Yohe. Her mother, Helen Yohe, owned the ponies and brought them from New Bloomfield. During the week, the ponies would stay on the grounds of the park. (Courtesy of Marilyn Stoner Swartz.)

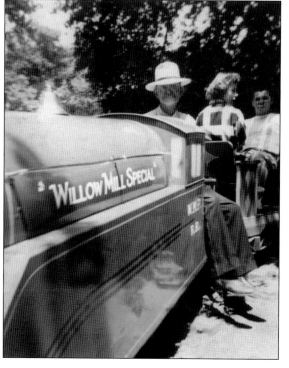

Harry D. Stoner drives the Willow Mill Special train, which carried passengers throughout the park and around the rides. (Courtesy of Marilyn Stoner Swartz.)

One of the major attractions at the park was Dynamite Dan, who would climb in a box with three sticks of dynamite and ignite them. Then, he would tumble out dazed but able to walk and repeat the act again for the next show—four hours later. At times, he had burns on his face. (Both, courtesy of Marilyn Stoner Swartz.)

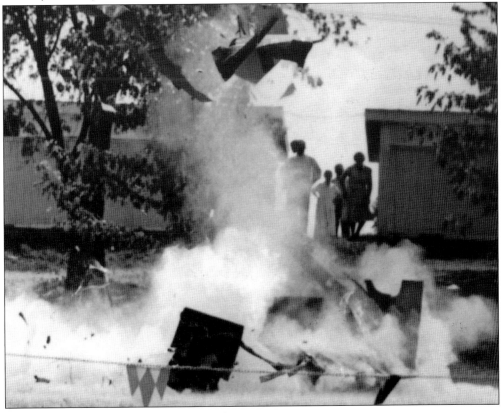

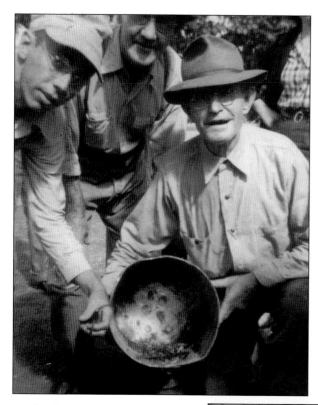

Harry D. Stoner shows a can of baby water snakes that he extracted from a mother snake found in the Conodoguinet Creek. There were a total of 65 snakes. The northern water snake is the most common water snake. They can grow to over four feet in length and can be brown, gray, amber, or brownish-black in color, although they become blacker with age. The belly of the snake also varies in color and can be white, yellow, or gray. The cross bands on their necks are dark, and they have what look like tire tracks on the rest of their body. (Courtesy of Marilyn Stoner Swartz.)

On a wintry day, Marlin Swartz posed with his son Michael in front of the Speed Boat ticket booth. In January 1941, a brutal winter wind blew across the Conodoguinet Creek at Willow Mill Park, causing an ice jam and a minor flood on the park grounds. Although the piling up of ice is not unusual for the creek, this particular ice jam created pressure at the creek's dam. An artificial channel had to be made on each side of the dam to help the ice flow. Willow Mill Park was closed during the winter months. (Courtesy of Kevin Swartz.)

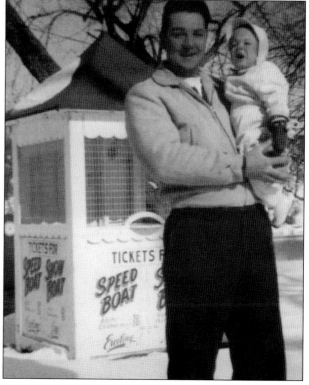

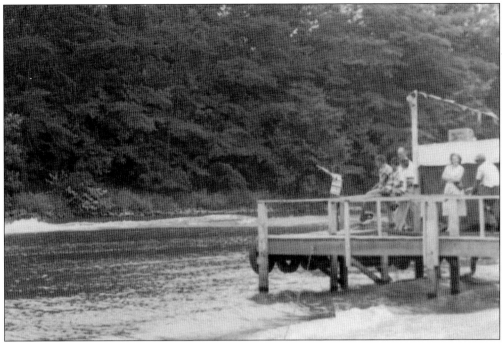

Above, excited patrons wait for their Speed Boat ride. The Chris-Craft boat thrilled its riders by moving at high speed on the Conodoguinet Creek. In 1915, the designer of the boat, Chris Smith, ran ads in *Power Boating* magazine encouraging readers to "Let Me Build You A Smith Boat." During World War II, the Chris-Craft Company began building patrol boats, utility launches, and rescue vessels for the US Navy and Army. In 1950, there were 139 different recreational boats available. (Both, courtesy of Marilyn Stoner Swartz.)

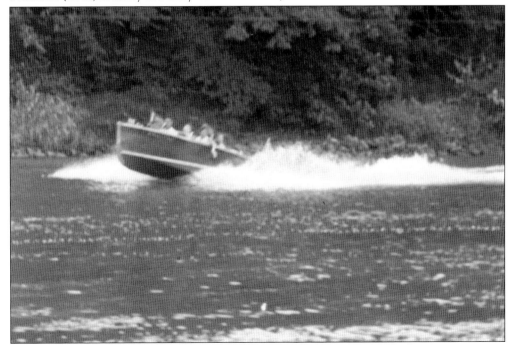

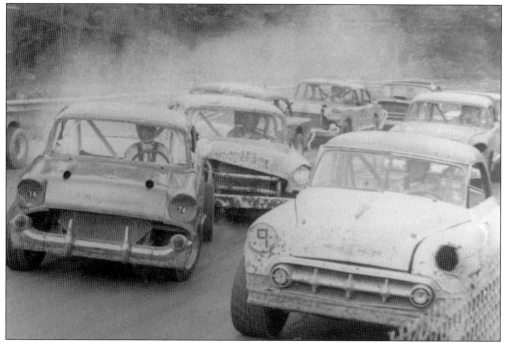

The Silver Spring Speedway was a major attraction both locally and throughout South Central Pennsylvania. After the racetrack closed in the 1990s, it was replaced by a mall, which caused a local uproar. (Courtesy of Alan Kreitzer.)

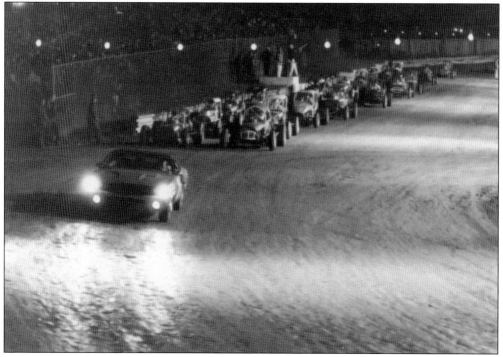

Night races at the "Springs," as the racetrack was affectionately called, were well attended by race fans. (Courtesy of Alan Kreitzer.)

The Sportsman cars with the top wings from the early 1980s are shown here. The cars are lined up in their starting order on the pace lap. The flagman can be seen signaling the drivers from the flag stand at right. Silver Spring Speedway was a very popular entertainment venue, attracting thousands of race fans on a Saturday night. Note the packed grandstands. (Courtesy of Alan Kreitzer.)

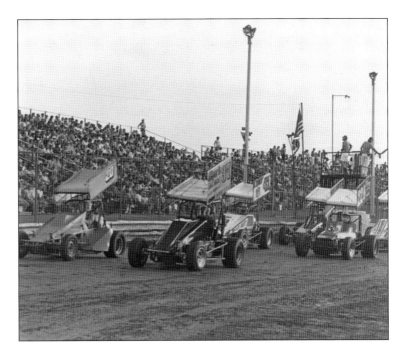

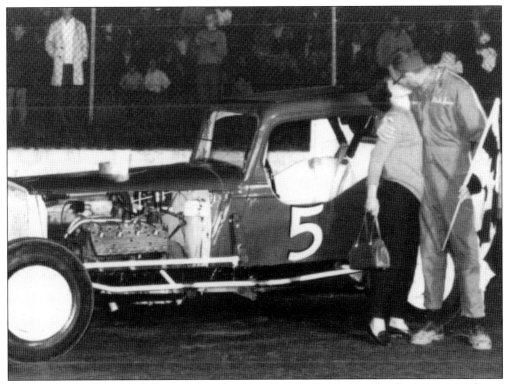

Mechanicsburg driver Dick Snare is warmly greeted in the winner's circle after a race win. Snare was the track champion in 1967 and 1968. Visible in the car is a Ford flathead engine, which was the predominant engine of the era. (Courtesy of Alan Kreitzer.)

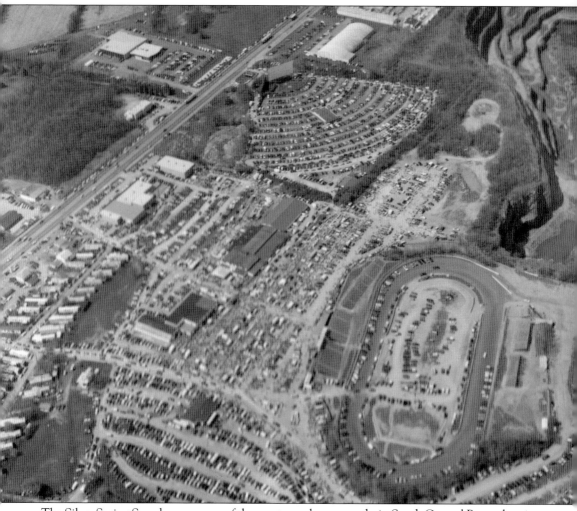

The Silver Spring Speedway was one of the most popular racetracks in South Central Pennsylvania. During its years of operation, the speedway ran over 2,500 feature events on the three-eighths-mile oval dirt track. The races were run on Saturday nights. In 1974, Donald Carter opened Carters Silver Spring Flea Market on the speedway grounds, which attracted 30,000 shoppers from the local community and beyond. The Silver Spring Drive-In Theater, located adjacent to the speedway, was a popular site for the community. During the summer holidays, it would have all-nighters, where movies were shown from dusk until dawn. On Sundays, the theater's parking lot was used for parking for the flea market. In 2005, the speedway and theater were removed to make room for a 460,000-square-foot shopping mall. (Courtesy of Alan Kreitzer.)

Polo matches have been held at Hempt Farms for many years. Max C. Hempt was a member of the West Shore Polo Club. The polo matches have developed into community fundraisers for the Multiple Sclerosis Foundation, the Eagle Foundation, and Channels Food Rescue. The polo committee changed the name for the Multiple Sclerosis Foundation fundraiser from Hempt Memorial Polo Match to George F. Hempt Memorial Polo Match in 2010. George F. Hempt was the son of Max C. Hempt. The events take place on the Hempt field, across from Cumberland Valley High School. (Courtesy of Max J. Hempt.)

Located at the intersection of Route 114 and the Carlisle Pike, the Rainbow Roller Rink opened its doors in the 1940s. It offered individual skating lessons and had a roller-skating party on New Year's Eve. Elementary schools took their students on class trips to get skating lessons. During the 1980s, the up-and-coming Mechanicsburg band Poison performed at the rink. There was a live organist, and hanging in the middle of the rink was a disco ball that shimmered when the lights were turned down. A popular drink from the soda fountain was a "Suicide," which was a combination of different soda flavors mixed together. Pictured at left are Diane Eckenrode Edmondson (left) and Nancy Mancine. Below are, from left to right, (kneeling) Earl McCulloch and Tom Samual; (standing) Glen Smith, Geoff Fishel, and Dean Schneider. (Left, courtesy of Nancy Mancine; below, courtesy of Geoff Fishel.)

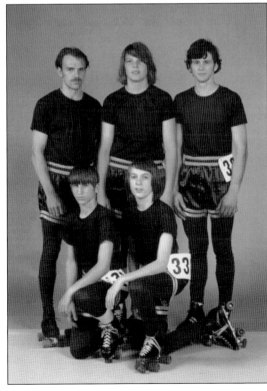

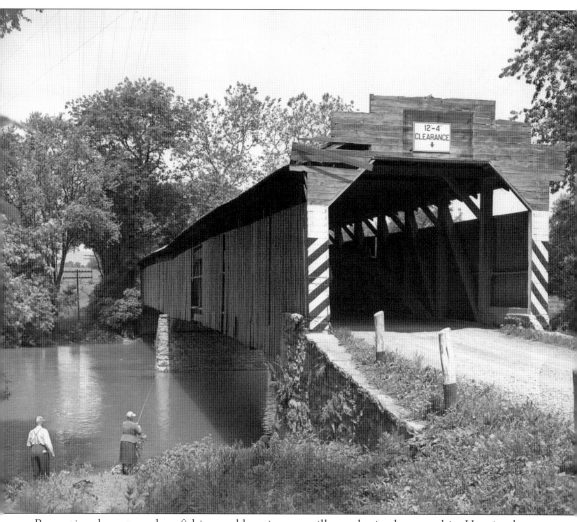

Recreational sports such as fishing and hunting are still popular in the township. Hunting has become limited due to development. Small game hunting—which included rabbits, squirrels, and pheasants—was once common. (Courtesy of Cumberland County Historical Society.)

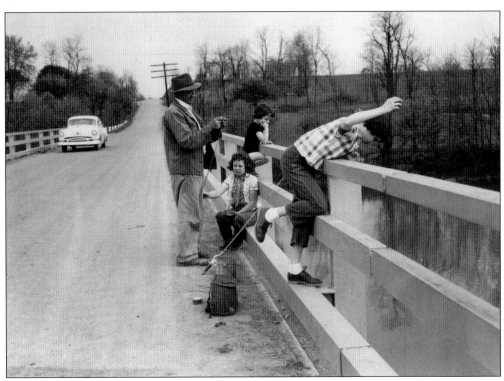

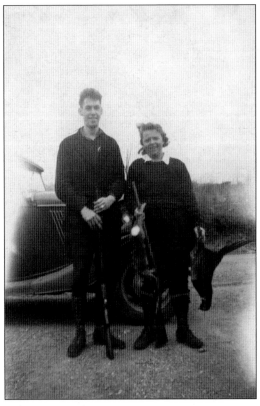

The Conodoguinet Creek is a valued waterway for fishing and boating. Bass are the primary fish taken from the creek. Along the creek, visitors can find herons, kingfishers, and other streamside creatures. On sunny days, the trees that border the creek and the sky are reflected in the water, making the world look upside down. Pictured above from left to right are Paul Konhaus, Ruth Konhaus, Nancy Konhaus Griffie, and Elaine Humer Sweger. At left are William Goetz (left) and sister-in-law Carolyn Rohland. (Above, courtesy of Elaine Humer Sweger; left, courtesy of William Goetz III.)

Ten
NOTABLE MENTIONS

James McCormick was a descendent of the early McCormicks who helped settle Silver Spring Township. He was four years old when he lost his father, William, in a farming accident on the Hogestown farm. He graduated from Princeton University and studied law with Andrew Carothers who lived in Silver Spring Township. McCormick was president of the Borough Council of Harrisburg, Dauphin Deposit Bank, the Harrisburg Bridge Company, and the Harrisburg Cemetery Organization. He married Eliza Buehler and had four children, Henry, James Jr., Margaret, and Mary. McCormick died on January 19, 1870. (Courtesy of Dauphin County Historical Society.)

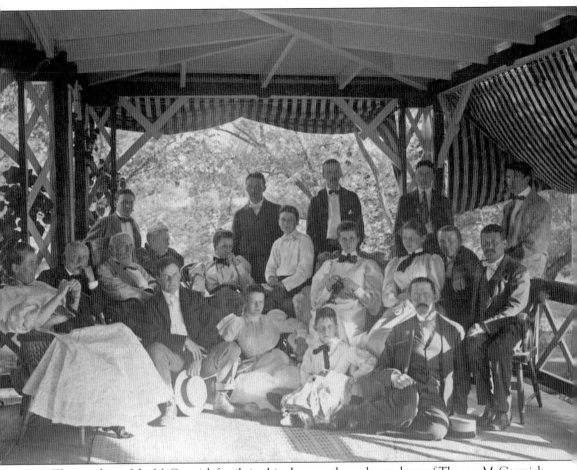

The members of the McCormick family in this photograph are descendants of Thomas McCormick, who settled in Silver Spring Township. The McCormicks were not only a prominent family in Silver Spring Township, but also internationally. According to the Center for Pennsylvania Cultural Studies page on the Pennsylvania State University Harrisburg website, "Each succeeding generation distinguished themselves in every field of endeavor, including business, finance, law, politics and the military." Other prominent Pennsylvania families that married into the McCormick family were the Camerons, Alricks, and Finneys. Col. Henry McCormick was the eldest son of James and Eliza Buehler McCormick. He enlisted early and became one of the first to defend the Union during the Civil War. After three months of service, he was chosen to be colonel to the First Regiment of the Pennsylvania Militia. Colonel McCormick was present during the 1863 shelling of Carlisle. He ran for Congress in 1882. In addition to their farm in Silver Spring Township, the McCormicks also had an estate at Rosegarden in Upper Allen Township. (Courtesy of Dauphin County Historical Society.)

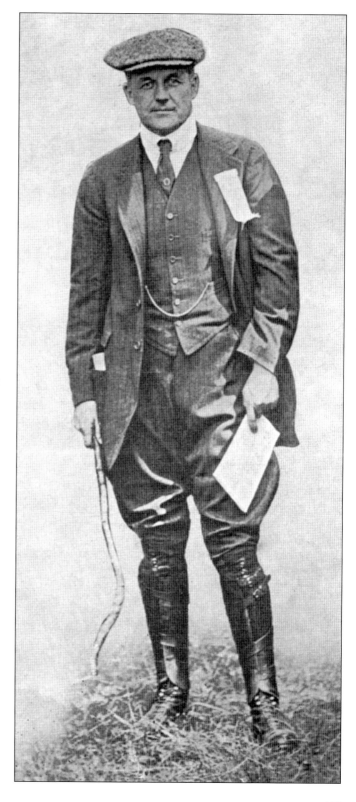

Born in 1872, Vance McCormick is the best known of the McCormicks. His parents were Henry and Annie Criswell McCormick. Vance was the mayor of Harrisburg from 1902 to 1905 and ran for governor. He became the chair of the Democratic National Committee in 1910 and again from 1916 to 1919. He was Woodrow Wilson's campaign manager and chair of the War Trade Board. In 1919, he was appointed by President Wilson to chair the Commission to Negotiate Peace at Versailles. Through all his prominence, he never lost sight of where he came from. Vance McCormick played a major role in starting the Stock Growers Association on the West Shore and the Hogestown Stock Show at Big Head Woods near Hogestown. Through the Stock Growers Association and the stock show, farmers learned how to be better farmers and how to produce better crops. Agriculture educators would attend the meetings and share their knowledge of farming. Vance McCormick was also a judge for the Hogestown Stock Show. (Courtesy of Dauphin County Historical Society.)

Pictured here are Raymond DeWalt and his wife, Sarah. DeWalt has been referred to as a dreamer, thinker, poet, philosopher, and inventor. Although he invented many medical and health devices and various types of machinery, he became best known for the Wonder-Worker, a radial arm saw that was, according to its advertisement, "constructed to perform 29 different cutting operations" and revolutionized woodworking. In 1932, Castle Lumber Yard purchased one of the first manufactured radial saws. DeWalt taught manual training at Mechanicsburg High School. He and his wife wrote and published poetry. Raymond DeWalt sold his patent to purchase Willow Mill Park. (Courtesy of Dolly Hupper Berkheimer.)

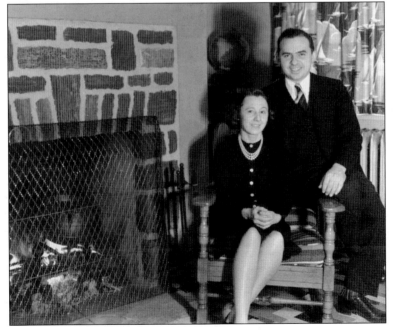

Lawrence Humer lived in Hogestown with his wife, Hulda. A professional photographer, Humer preserved history through his photographs and produced Christmas cards for various businesses throughout the Silver Spring Township area. The home he lived in was originally purchased by his father and is still in the Humer family. (Courtesy of Elaine Humer Sweger.)

The Hempt family has played a major role in the development of Silver Spring Township. Max C. Hempt, founder of Hempt Brothers Inc., a crushed stone and concrete business, owned the internationally renowned Hempt Farms, where he raised world champion standard bred horses. Hempt's standard bred filly, Stenographer, won horse of the year in 1954; quite the achievement for a filly. Hempt financially backed the water line from New Kingstown to Cumberland Valley High School in the early 1950s. He helped to purchase a fire engine for the township and supported the relocation of Hempt Road, which once ran through Hempt Farm. The road now stretches from the Carlisle Pike to Texaco Road, making passing through that area of the township less dangerous than when it wound through the Hempt farmland. Hempt donated the land for Cumberland Valley High School and the Cumberland Valley School District's administrative offices. He also donated the land where the Silver Spring Ambulance is housed. George Hempt, pictured here, was the son of Max C. Hempt and continued his father's philanthropy efforts. George's father helped to develop the West Shore Polo Club, and through that, the Hempt family contributes time, money, and the location for fundraising events such as the Central Pennsylvania Chapter Multiple Sclerosis Foundation, Channel Foods, and the Eagle Foundation. After George Hempt's passing, the polo event for the Multiple Sclerosis Foundation was renamed the George F. Hempt Memorial Polo Match. (Courtesy of Max J. Hempt.)

Pastor Thomas J. Ferguson served as minister at Silver Spring Presbyterian Church for 50 years, making him the longest-serving pastor of the church. In 1911, he was a member of the House of Representatives, and in 1920, he ran for the Senate. He was a delegate for the Constitutional Convention in 1921 and served as president of the Allen and East Pennsboro Society for Recovery of Stolen Horses, Mules, and the Detection of Thieves. He was also president of the Presbyterian Reunion Association. During World War I, he was a member of the Man Behind the Plow planning committee. Pastor Ferguson passed away on August 4, 1937. (Courtesy of Silver Spring Presbyterian Church.)

Pvt. Henry Walter, whose house was located at 46 West Main Street in New Kingstown, served in the Civil War. At the age of 26, Private Walter quit his job and volunteered for the Union Army. After less than two months of training, he and his unit, under the leadership of Gen. Ambrose Burnside, marched into Fredericksburg, Virginia, while en route to the Confederate capitol of Richmond. In Fredericksburg, the unit was confronted with Confederate soldiers. After losing 12,500 men, the unit retreated to the Rappahannock River. Later, the unit again attempted to make its way to Richmond, but torrential rains hindered their march, which has been infamously named the "Mud March." Private Walter fought in four major battles and nine minor battles during the Civil War. He was captured and paroled, gravely wounded, and endured cold, mud, fire, and scorching heat. He received an honorable discharge on October 25, 1864. (Courtesy of Silver Spring Township Veterans Memorial Committee.)

James Williamson Bosler was born in Silver Spring Township in 1833. His father owned a farm near the Conodoguinet Creek, where he also ran a distillery. J.W. Bosler completed his education as a youth at the school in New Kingstown and later attended Dickinson College. Having a taste for adventure, Bosler left Pennsylvania for the West. In the early 1850s, he played a major role in the settling of Sioux City, Iowa. He financially supported the building of the first school in Sioux City and its courthouse. He also helped to lay out the county of Woodbury, Iowa. He moved farther west to Nebraska, where he purchased land and began raising and trading Texas Longhorns. Bosler rose to prominence through his clever business dealings. He was a good friend to many politicians of the day. In 1883, he ran for the Senate in Pennsylvania but lost by a small margin. After his death, Bosler Hall was built on the grounds of Dickinson College. Bosler, Wyoming, is named for him. (Courtesy of Dickinson College Archives.)

Paul Konhaus was a well-known businessman throughout South Central Pennsylvania. Turkeys were his business. The family had seven farms and was well known for their Guernsey cows. They had a bottling plant and delivered milk within a 20 mile radius. With the advent of the paper milk carton the focus of the business shifted to the turkey industry. Paul Konhaus was able to turn his milk business into a successful turkey business that led to the ownership of five full size grocery stores. Konhaus was also an active community member. He was vice president of the board of directors of the First Bank and Trust, currently PNC Bank, in Mechanicsburg. He served on the board of directors of the former Seidle Memorial Hospital, and was president of Harrisburg Executive Club and the Mechanicsburg Rotary Club. He was also a member of the board of supervisors of Silver Spring Township in the 1960s. (Courtesy of Nancy Konhaus Griffie.)

A veteran of World War I, Sen. George N. Wade spent 32 years in the Pennsylvania Senate. In the 1930s, he purchased a small farm outside of Hogestown that was once owned by John Hogue. Senator Wade was part of a group of land owners and farmers who donated portions of their farms for the conservation and preservation of the Conodoguinet Creek, the senator's being the largest land donation. The Interstate 81 bridge that crosses the Susquehanna River near Harrisburg was named for him in 1973. (Courtesy of Betty Wade.)

Sen. Patricia Vance has lived in Silver Spring Township since 1964. She is a professional nurse and has been a state senator since 2005. Prior to her current position, she spent 14 years in the Pennsylvania House of Representatives. Though her schedule as a senator is very busy, she still finds time to be a part of several charitable, community, and religious organizations, including the Stabler Foundation and the Caring Place. (Courtesy of Sen. Patricia Vance.)

Bibliography

Barton, Michael and Vance Criswell McCormick. *Citizen Extraordinaire*. Mechanicsburg, PA: Stackpole Books, 2004.

Bell, Raymond Martin. *Mother Cumberland: Tracing Your Ancestors in South-Central Pennsylvania*. New York: Heartside Press, 1989.

Conkin, Paul K. *A Revolution Down on the Farm: The Transformation of American Agriculture since 1929*. Lexington, KY: University Press of Kentucky, 2009.

"History of Cumberland and Adams Counties." USGenWeb Archives. files.usgwarchives.net/pa/cumberland/history/local/beers1886/beers-33.txt

History of Silver Spring Township (booklet). 1976.

Schaumann, Mary Lou. *Taverns of Cumberland County 1750–1840*. Lewisberry, PA: W&M Printing Inc., 1994.

Discover Thousands of Local History Books
Featuring Millions of Vintage Images

Arcadia Publishing, the leading local history publisher in the United States, is committed to making history accessible and meaningful through publishing books that celebrate and preserve the heritage of America's people and places.

Find more books like this at
www.arcadiapublishing.com

Search for your hometown history, your old stomping grounds, and even your favorite sports team.

Consistent with our mission to preserve history on a local level, this book was printed in South Carolina on American-made paper and manufactured entirely in the United States. Products carrying the accredited Forest Stewardship Council (FSC) label are printed on 100 percent FSC-certified paper.